COUNTRYSIDE

Bruce Robertson

HarperCollinsPublishers

First published in 1993
by HarperCollins*Publishers*, London
Reprinted 1994, 1995, 1996

© Diagram Visual Information 1993

Editors: Millicent Bagel, John Morton
Art Director: Darren Bennett
Contributing artists: Laura Andrew, Peter Campbell,
David Cook, James Dallas, Kyri Kyriacou, Lee Lawrence,
Ali Marshall, Philip Patenall

A catalogue record for this book is available from the British Library

ISBN 0 00 412671 8

Produced by HarperCollins Hong Kong

CONTENTS

Tools and Equipment

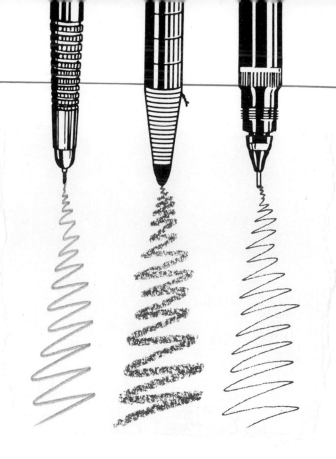

Pencils

Few drawing tools match a pencil's versatility. It can be used for rapid sketches or to create detailed studies.

Pencils are classified by hardness: 9B is the softest and 9H is hardest – HB is in the middle. Softer grades make thicker, heavier marks and permit greater variation in tone; harder grades make finer, fainter lines.

Pencil erases easily, particularly the soft grades. You can blend or smudge pencil with a finger to soften lines or to make special effects.

There are different types of pencil: propelling, clutch, wax and coloured pencils. Experiment with the different kinds to discover the various effects they can produce and which you prefer.

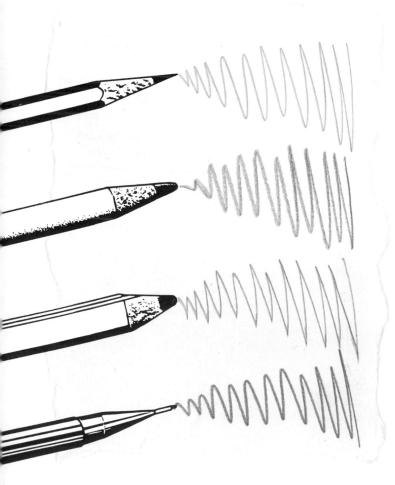

The landscape below was sketched rapidly in 6B pencil on cartridge paper, as the thick strokes and lack of detail show

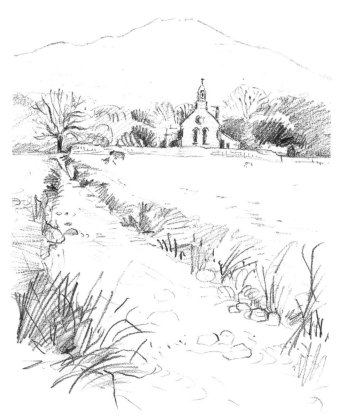

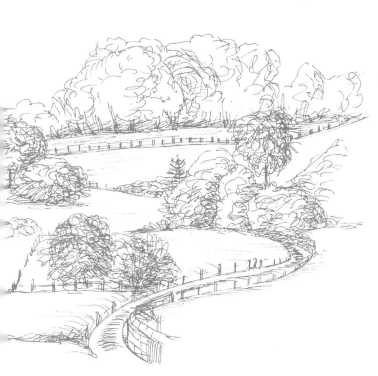

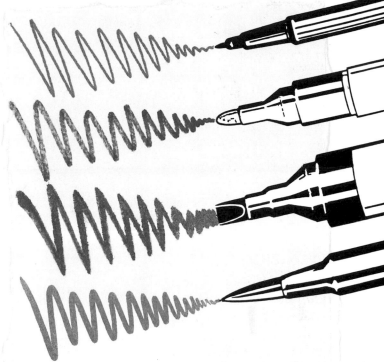

A technical pen on cartridge paper produced the sketch above. I used a fine nib to add detail, such as the fence posts

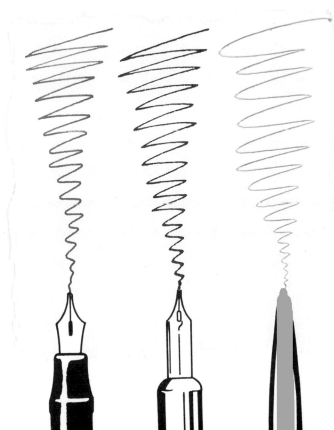

Pens

Experiment with the wide variety of pens available to see which type suits you best. Ink can't be erased, so it's often best to make a pencil sketch before inking in your final lines.

Ball-point pens are good for light sketches but not for close detailing or shading, which can become messy.

Felt-tip pens are available in many different widths and bright colours. They can be used for strong detail; thick-nibbed **studio markers** can be used more like a brush to cover large areas.

Technical pens are good for careful, detailed work needing even line strengths.

Fountain pens can be carried in your pocket; **dip pens** allow you to exploit a vast range of coloured inks. Both these types of pen are available with different nib widths. They give fluid lines, and more or less pressure on a nib will produce thicker or thinner ones.

Look after your pens – replace caps on felt-tips and clean technical or dip pens after use.

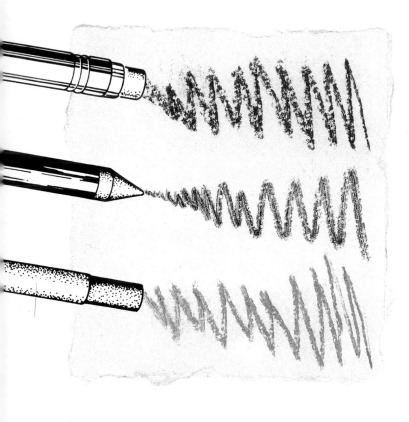

Pastels and crayons

Pastels and crayons can bring a wide range of textures, lines and tones to your landscapes. Their bright quality can animate a drawing in a way that other media can't.

Oil-based pastels and **wax-based crayons** are made in a myriad of strong, vivid colours that can simulate oil paints. Though poor for detail, they can be used with other media to create glowing effects and to add attractive texture.

Pastels are not easy to erase but, like pencils, you can rub them with your finger or a rubber to soften edges, blend colours or create special effects.

Wax-crayon colours are best blended by making overlapping cross-hatched lines on the paper, though excessive shading will turn bright colours into a muddy mess.

I used pastel on textured paper to illustrate the gentle tranquillity of these hillside fields

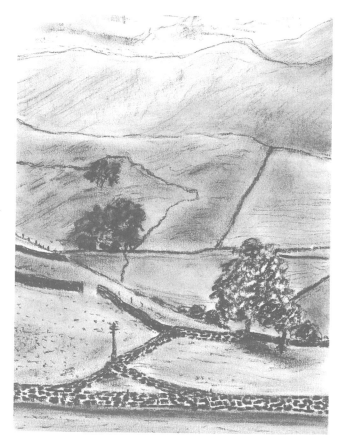

Charcoal and conté crayon

Harder than pastel or crayon, a **charcoal stick** can be used for fine or bold strokes. You can use its side rather than its tip to shade large areas. Charcoal produces a wide range of marks from delicate, light strokes to thick, velvety blacks. Charcoal smudges and breaks easily – you will become accustomed to using it with practice.

Charcoal strokes can be erased or smudged with a finger to soften lines. Use a kneadable putty rubber to help pick out highlights in shadow.

Conté crayons are also supplied as sticks but are slightly greasy and harder to erase. Less fragile than charcoal, they are available in black, white, sepia or terracotta.

The stark contrast of tones, in this brightly sunlit field, is conveyed by charcoal on textured paper

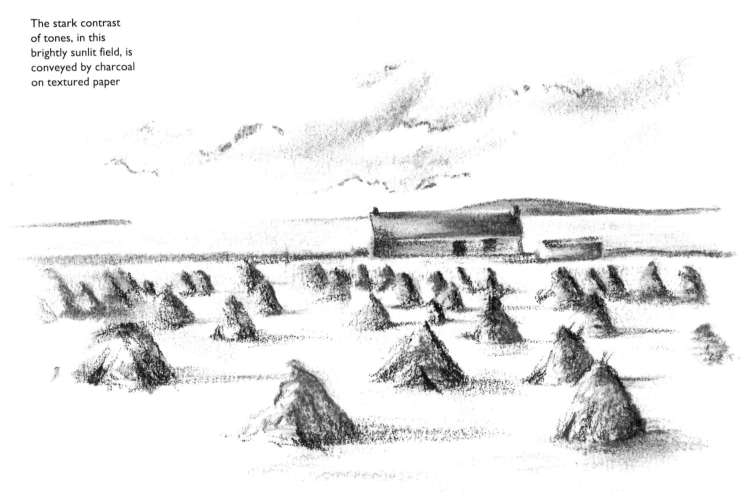

Brushes

A brush can create strokes ranging from the bold and powerful to the fine and delicate.

Brush tips are made in a range of lengths and widths, each having a particular function.
Long-tipped, pointed brushes may be used to make thick or thin strokes.
Short-tipped, pointed brushes allow greater control and are best for fine detail.
Short or long **flat** brushes are used to cover large areas of a painting.

Fibres used for brushes vary from expensive, long-lasting sable or squirrel hair to cheap synthetics, which suffice for most work.

Handle your brushes with care to avoid impairing the bristle 'spring'. Clean them properly after use and store them upright.

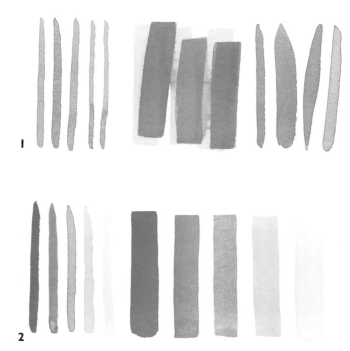

1

2

1 Using watercolour, these different strokes were made with (*from left to right*) a small, pointed-tip brush; a flat brush; and a large, pointed-tip brush

2 Here, the effect of varying amounts of water on watercolour tone is shown. Greater quantities of water produce lighter tones

3

5

4

6

3 To keep a uniform tone when painting, cover the area with a light wash. Then, while it's still wet, build up the tone with darker washes

4 Brushing watercolour over dry paint prevents mixing and gives distinct edges between layers

5 Paper dampened with a little water will absorb watercolour, creating a soft, delicate area of colour with ill-defined edges

6 Ink or concentrated watercolour brushed on to damp paper can create unusual effects

Wet media

Oil paints are expensive, not water based and are hard to use. They take a long time to dry.

Paints and inks that are water based, however, can be diluted in order to vary colour strengths. Transparent **watercolour** lets pencil work and paper show through. A red, for example, can be used as a concentrated red or diluted to the most delicate rose tint. Used on absorbent, thick paper, watercolour gives subtle, muted effects.

An opaque **gouache** watercolour produces bold, solid colour. Only paper textures show through. Opaque **acrylic paints** give strong, vivid colours, which, when used very thickly, can resemble oils, but they may be diluted with water. When working with a wet medium, use heavy paper that won't buckle.

I used strokes of varying thickness and differing concentrations of watercolour to depict the contours of this landscape

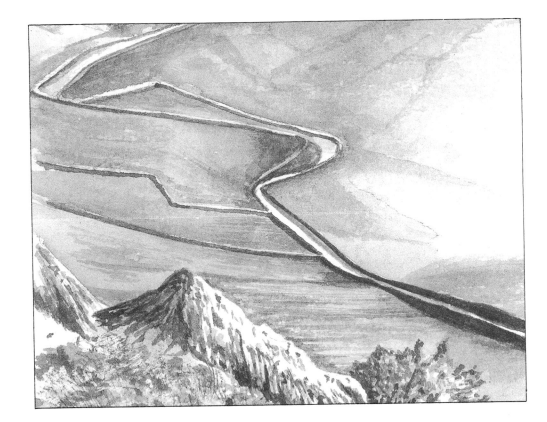

The grasses in the foreground below were painted using fine, delicate watercolour strokes on watercolour paper

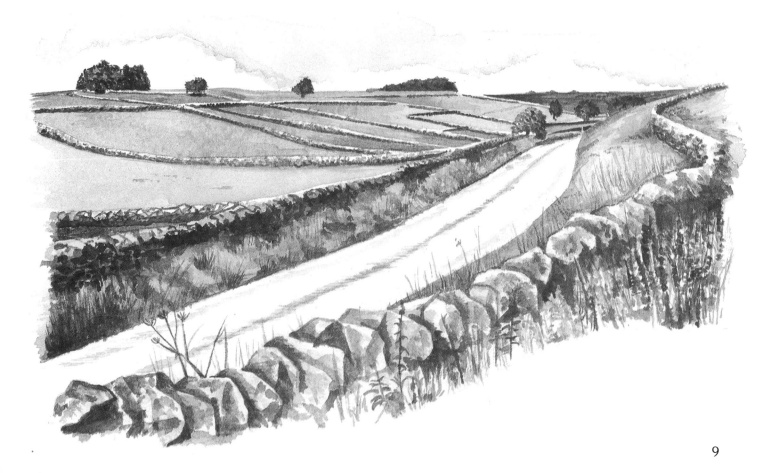

Surfaces to draw on

Two elements determine the feel of a sketch –
your drawing tool and your drawing surface.
When choosing a drawing surface, you should
think not only of the final effect you want – the
rich and detailed contrasts of different summer
leaves and flowers in a country lane or a subtle,
atmospheric sunset reflected on a lake – but
also of the drawing medium you've chosen –
watercolour, charcoal, pencil and so on.

Each drawing tool tends to be best suited to
a certain type of surface. Pastel, for example,
does not work well on shiny surfaces – it
needs a rough texture to which the particles
can cling. Paints and inks need thick, fairly
absorbent paper. It's worth experimenting with
different tools on different surfaces to discover
what suits you best and which effects you find
most pleasing.

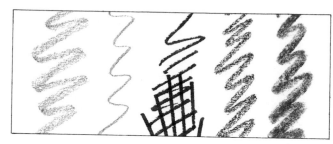

Newsprint is
inexpensive making
it good for sketching
and practising

Tracing paper is
semi-transparent so it
lets you trace other
images quickly

Stationery paper is
usually available in
one standard size. It
works well with pen

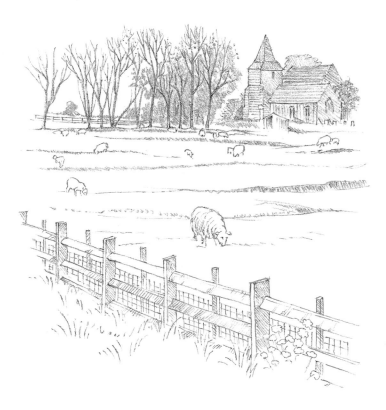

The clean, crisp lines of
this country scene were
made using a 2B pencil on
layout paper

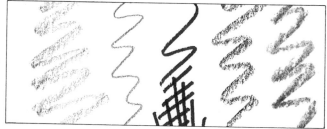

Cartridge paper, usually
textured and of a high
quality, is one of the most
versatile surfaces

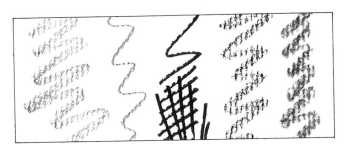

Ingres paper is often used with charcoal or pastels. It is available in white and pale shades

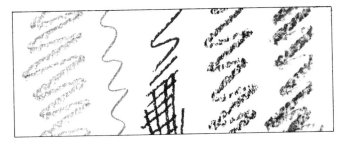

Watercolour paper is thick and absorbent, so it works well with wet media

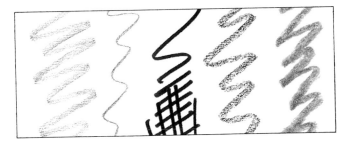

Bristol board is stiff, with a smooth surface, and is best for pen drawings

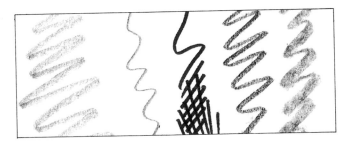

Layout paper is a semi-opaque, lightweight paper that works best with pencils and pens

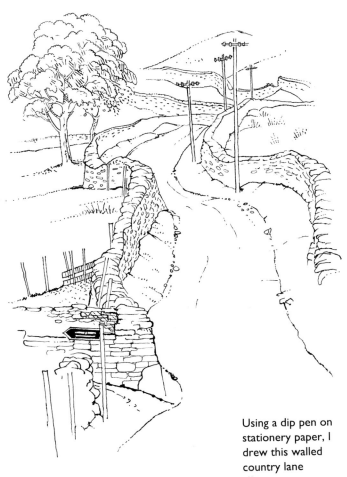

Using a dip pen on stationery paper, I drew this walled country lane

Types of paper

There are three ways of making paper. Expensive **handmade paper** is very durable and provides the best surface; because it's hand-crafted each sheet is slightly different. Machine-made **mould paper**, like handmade paper, is produced in single sheets but is more uniform, and has a right and a wrong side. **Machine-made paper** sheets, cut from continuous rolls of paper, are of uniform quality.

Paper finishing treatments add distinctive textures. For example, hot-pressed paper is smooth. Patterns on moulds that form wove or laid paper give a continuous surface texture.

The surfaces in the centre of these pages each show (*from left to right*) marks made by a 3B pencil, a 2B pencil, a felt-tip pen, a conté crayon and a charcoal stick.

Choosing the Right Medium

The pictures here show the same wooded stream. Yet each illustrates the unique results you can achieve by combining different drawing surfaces with various tools. Combinations like a dip pen on cartridge paper (**6**) obviously convey much fine detail. Others, like the blended pastels on cartridge paper (**7**), cannot match such detail, but may lend a bright or lively quality.

Familiarize yourself with various combinations of surfaces and tools. Once you know what you can achieve with them, you'll find it easy to select those best suited to convey whatever mood or detail attracts you in a landscape.

These drawings were made with the following paper and tool combinations:

1 Charcoal on textured paper
2 6B pencil on cartridge paper
3 Watercolour on watercolour paper
4 Felt-tip pen on cartridge paper
5 Coloured pencil on watercolour paper
6 Dip pen on cartridge paper
7 Pastels on cartridge paper

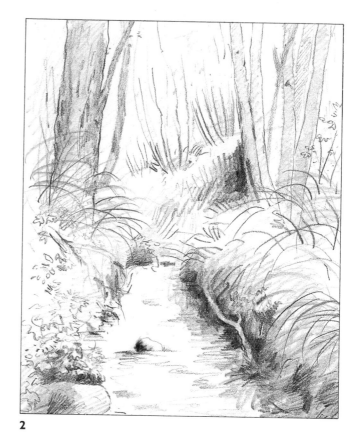

2

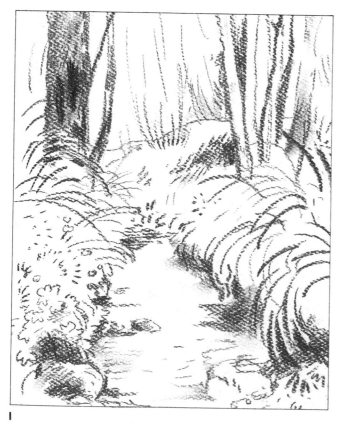

1

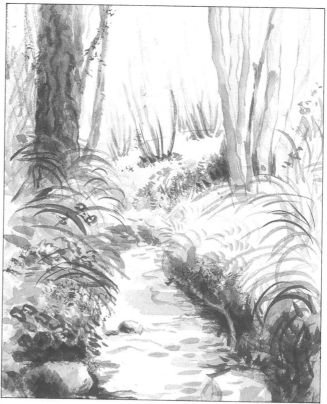

3

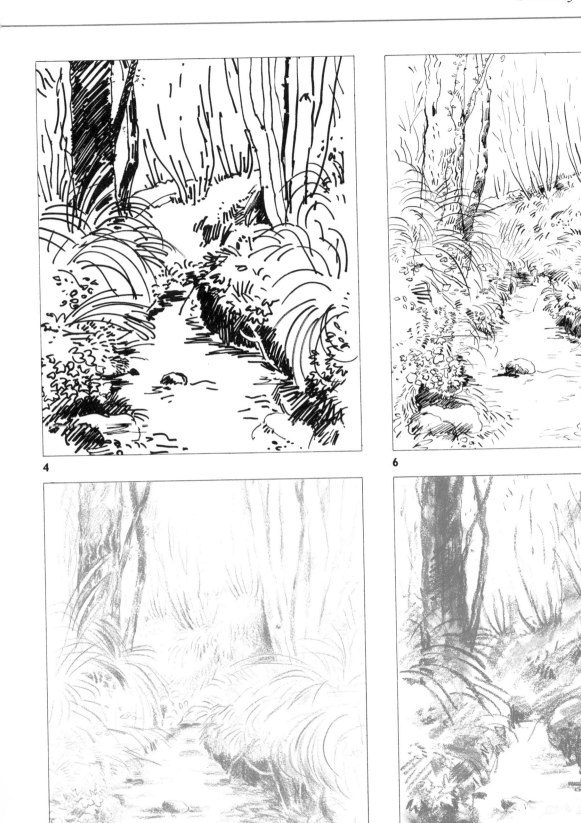

4

6

5

7

Measuring in Drawing

Reproducing what your eyes see is hard, for a realistic landscape drawing accurately depicts relative sizes of distant and close elements.

Pencil measuring

Holding a pencil upright, thumb uppermost, in your outstretched hand (*right*), line up the pencil tip with the top of the object you are measuring. Mark the bottom of the object with your thumb and move the pencil to the paper to transfer the measurement. You can use the same basic method to measure widths. Hold your pencil at a slant to check the angles of slopes.

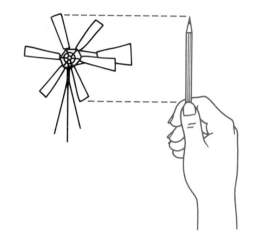

Verticals and horizontals

A useful aid to drawing objects with their correct relative proportions and positions is a simple grid on which you can locate the main features in your landscape.

First of all, draw a faint horizontal line across the middle of your paper. Now add a central vertical down the paper's length. These central lines of your grid will be reference points against which you position the elements of your landscape. For the vertical measurements, use your pencil to measure above and below your horizontal grid lines. For the horizontal dimensions, transfer your pencil measurements to either side of the relevant vertical grid lines. In this way, you can accurately add horizontals, verticals or inclines to build up the basis of the drawing.

Construct your drawing in a logical way. Try not to do too much at once, otherwise you could confuse your eye and become discouraged. First, lightly outline the main horizontal and vertical structures, such as hedgerows and tree trunks. Once you have the skeletal composition, flesh it out with secondary, smaller structures, using the same measuring techniques. Then, last of all, add fine detail, incorporating light and shade (pp. 18–19), and texture (pp. 20–21). How to build up your sketches in this way is explained and illustrated in detail on pp. 22–27.

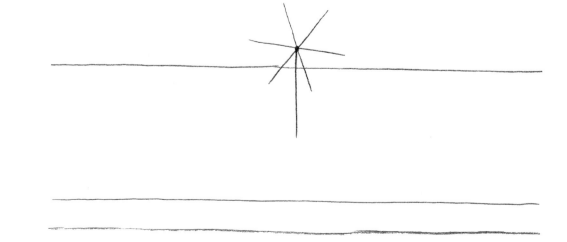

I formed my landscape grid (*right*) by using the horizon line as a guide for positioning vertical measurements and the central windmill mast for horizontal ones

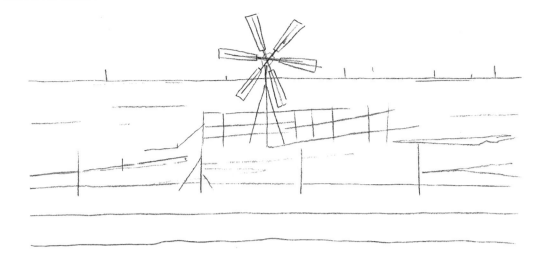

Carefully working in sequence against the grid, I used pencil measuring to find the correct positions and proportions of the main elements (*left*)

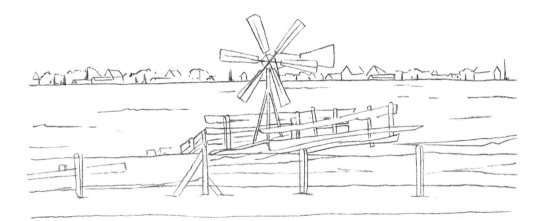

After I'd outlined the main elements, I added details such as the fence boards (*left*)

Once I had included all the forms, I added tone and shading to depict a wintry Dutch landscape accurately in 3B pencil (*below*)

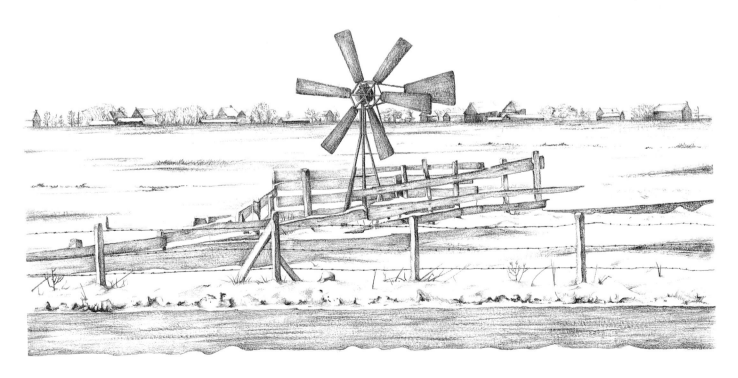

Perspective

Viewpoint and eye-level

The position from which you look at a country scene is called your **viewpoint**. In a flat, uninterrupted landscape, sky and land meet at the horizon. The horizon will be at your **eye-level** – an imaginary horizontal plane running from your eyes as far as you can see.

Vanishing point

Looking at the drawing below and its diagrammatic representation (*right*), you can see that the rough horizontal line formed by the bases of the trees slopes up towards your eye-level. The line formed by the branches, however, slopes down to it. You can also see how all the receding horizontal lines converge on one point – the **vanishing point**.

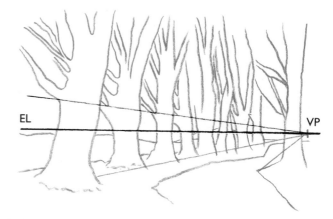

In the drawing below, the trees on the left of the avenue are the main focus. They carry the eye to a vanishing point on the right

You can see, in the diagram above, how the horizontal receding lines converge on a vanishing point (VP) at your eye-level (EL)

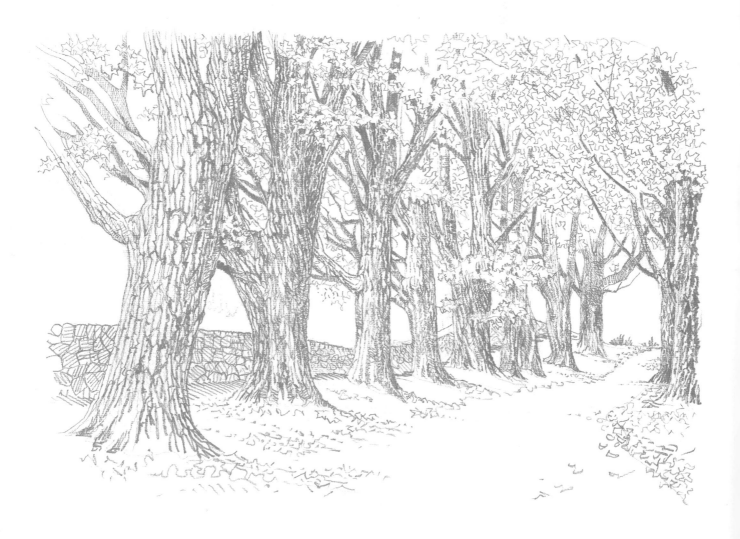

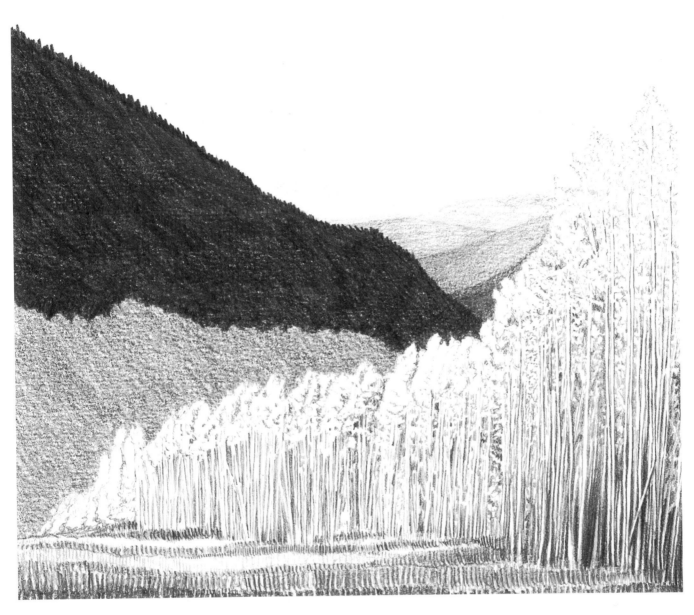

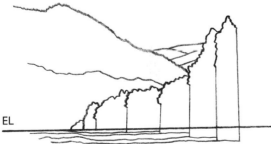

These trees (*top*) become shorter and less distinct as they recede. I used progressively lighter tones on the hills to give depth

In the diagram above, note how overlapping shapes convey size and detail, and objects' relative positions in space

Changing your viewpoint will alter the position of your vanishing point, and the perspective of your composition.

Size, colour and detail

Objects on land and cloud formations in the sky diminish in size and detail the further away they are. Colour, too, is softened and tends to become paler and more blue as objects recede. Spaces between trees, hills and buildings also decrease in size with increasing distance, until objects that are far apart appear to be next to each other.

Light and Shade

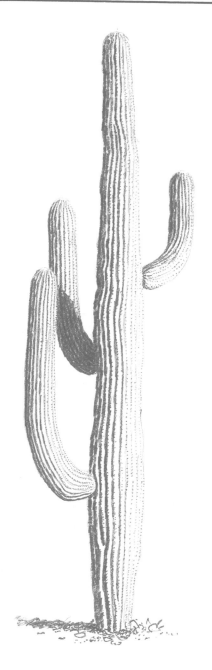

Tone

Strong sun on a desert scene produces jet-black shadows and glaring highlights separated by an infinite variety of greys – the scene has **high contrast**. But weaker sunlight will not create such extremes, and so a **low-contrast** range of mid-greys would be seen.

A **high-key** scene, such as a snowscape, contains mainly pale tones; a **low-key** picture, such as the one below, has mainly dark tonal values. Key and contrast can add mood and a sense of time.

Position of the light source

Daytime outdoor scenes have one light source – the sun. When drawing a landscape, ensure you know the sun's position and thus where the light comes from. Make sure each element of the picture is lit from the same direction.

The left side of this cactus (*left*) is 'in shadow' – the light source is on the right. Shading also helps to show its round form

This B-pencil drawing, on textured paper, of a stile (*below*) shows strong shadows cast by bright light over the planks

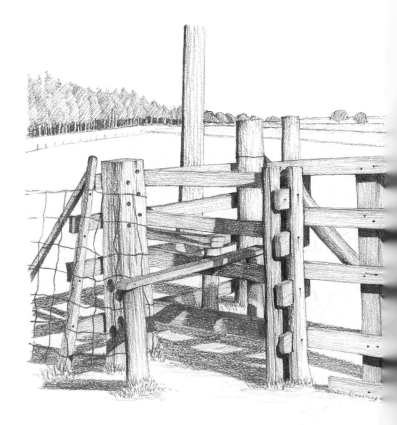

Shading in drawings can depict shadows on landforms and add a sense of depth to your compositions.

Shadow

There are two types of shadow: a hillside that faces away from the sun is dark – or **in shadow**; when an object obstructs light, it creates a **cast shadow**. Both often overlap; this can be shown by overlaying shading of different strengths. Shading can help to show protruding or receding surfaces.

The sun was low in the
sky, behind these hills,
when I painted them
using watercolour on
watercolour paper. I used
mottled darker tones for
nearer detail; lighter
washes were used for the
more distant hills

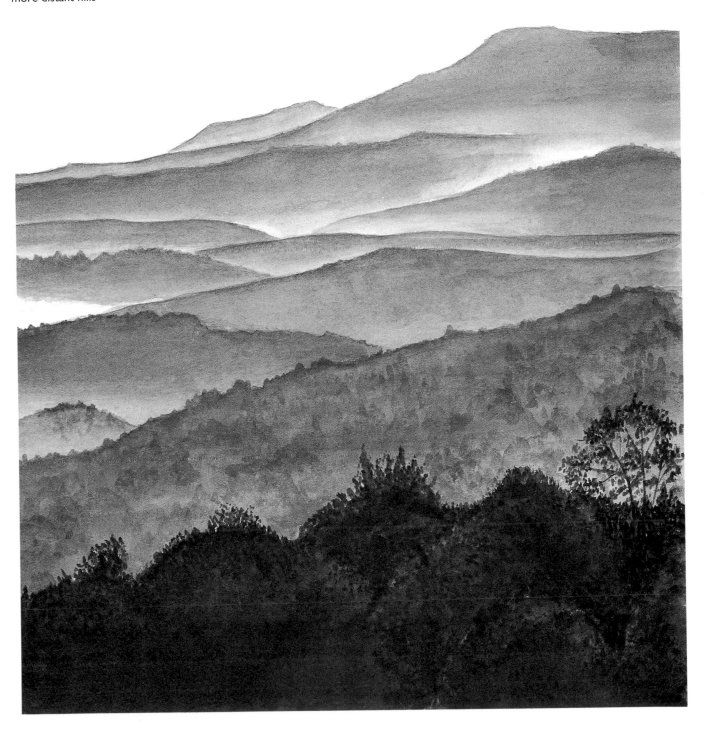

Surface Texture

The countryside possesses a mass of different textures. An accurate depiction of a landscape involves representing these in all their variety – the roughness of bark, the 'fluffiness' or 'featheriness' of a cloud, or the smooth surface of a calm pond.

The seasons affect the texture of the countryside: the soft, rounded, leafy canopies of deciduous trees in summer are vastly different from the sharp angularity of bare branches in winter.

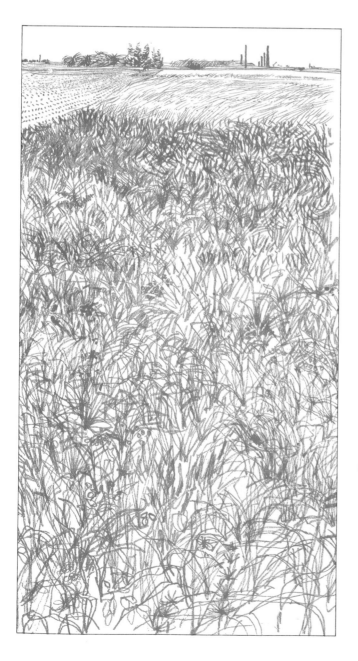

The three different textures of a ploughed field, a sown field and one of wild grasses (*left*) were depicted in pen

I conveyed the different textures of the various plants above by using marks of varying lengths and thicknesses

Representing real texture

A simulated texture is a 'shorthand' way to draw the real texture of, say, every single leaf on a tree. Rather than covering a whole hillside in individual blades of grass, it may be better to suggest these by drawing a few single examples in the foreground of your landscapes. The rest of the hillside's texture can be suggested by using contrasts of light and shade, by exploiting the texture of the paper and the tool you use, or by using patterns of lines. For example, in the foreground of the landscape on the left, individual grasses were drawn in detail to show their texture. In the background, though, detailed representation gave way to the use of stippling to depict the ploughed field and sloping strokes to show a field of wheat.

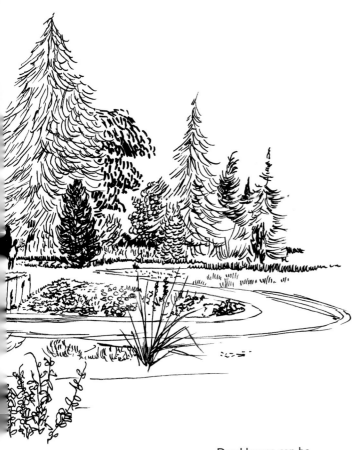

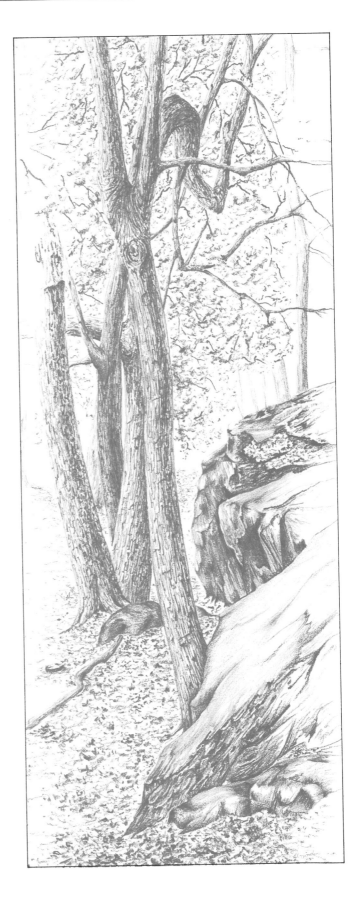

Dead leaves can be shown by simple pencil strokes (*right*). Note that much of the rock surface has been left blank

Try various methods and media to express textures like rocks or leaf and flower forms. Explore different ways to convey the same texture.

Mood and texture

Abstract simulations of texture can be used to lend mood or atmosphere to your drawing. An impending thunderstorm, for example, could perhaps be represented by using the qualities of charcoal on rough, textured paper to show the dark, threatening nature of thunder clouds.

Try inventing textures that don't mimic reality but convey mood. Soon you'll have a wide range of techniques to deploy on any sort of landscape.

Sketching

The 2B-pencil sketch (*above*) shows the use of basic shapes – squares for the buildings and curved shapes for the background foliage

I used a pen to sketch these mesas and buttes (*below*). The light was very hard and bright, thus the contrast is high and the detail clear

Developing your sketching skills

The illustrations in this book can only hint at the infinite variety of drawing styles you can adopt. Art books on great landscape artists can supply more ideas. Experiment in a sketchbook to find your own style.

Open-air sketching is best for developing your powers of observation and your ability to interpret the countryside around you. Try to carry a sketch pad at all times, especially if you visit somewhere for the first time.

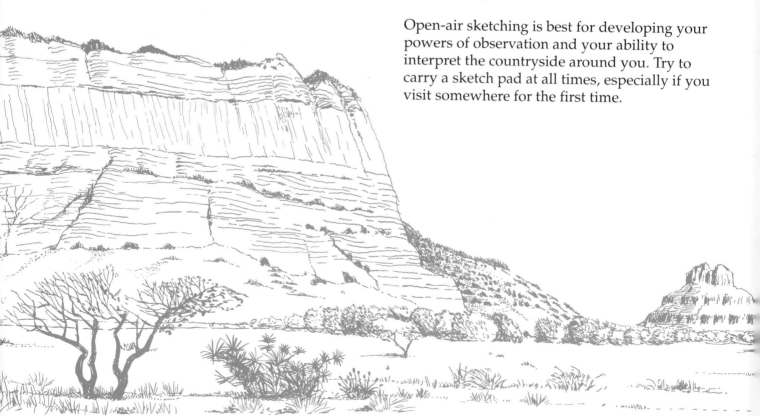

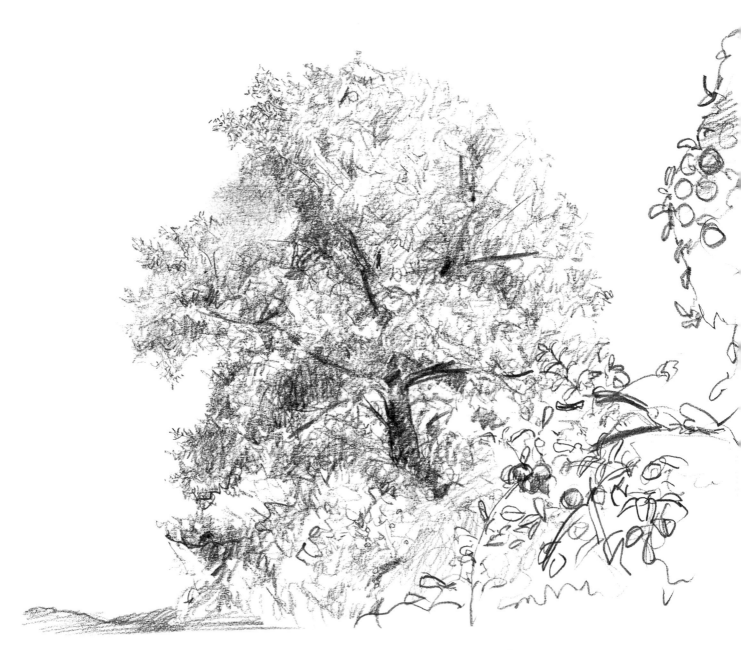

I captured the vitality of
the high-summer foliage
depicted above with rapid
2B-pencil strokes

Keeping your sketches

Your sketchbook will come to include a variety
of material, from careful preparatory studies for
formal landscapes (annotate these with notes on
textures, colours and anything else that may
help you later) to rapid sketches of attractive
details, such as a cloud formation or a twisted
tree. You should never throw away old
sketchbooks – they will make a fascinating
record of your travels, and you'll be able to refer
back to them for details that you can incorporate
in larger pictures.

Timing your sketching

Many attractive subjects appear only fleetingly – towering clouds scudding across the sky, a horse and cart trundling down a leafy lane, or the drama of sunbeams breaking through black storm clouds. Rapid sketching is essential to capture the essence of such transient scenes.

You need to concentrate on the most important parts of a subject if time is short – add detail later, perhaps on another day. A good way to develop speed is with series of timed sketches of the same landscape. Set yourself a time limit of one minute for the first sketch. Then go on to do two-, five- and twenty-minute sketches.

Compare your sketches with the real view, checking that, within your time limits, you focused on the most important elements.

Even if time is unlimited, rapid work can still be beneficial – a spontaneous sketch can convey far more than a laboured, detailed drawing that may be, in the end, stiff and lifeless.

In the two-minute sketch below, I tried to capture the basic shapes of the whole scene, knowing I could fill in the detail later

I took five minutes to produce this sketch (*above*). The basic shapes of the tree-tops in the background and details, such as windows, have been added

Giving myself twenty minutes, I worked on portraying the atmosphere of the scene opposite, adding shading and detail with HB and B pencil on cartridge paper

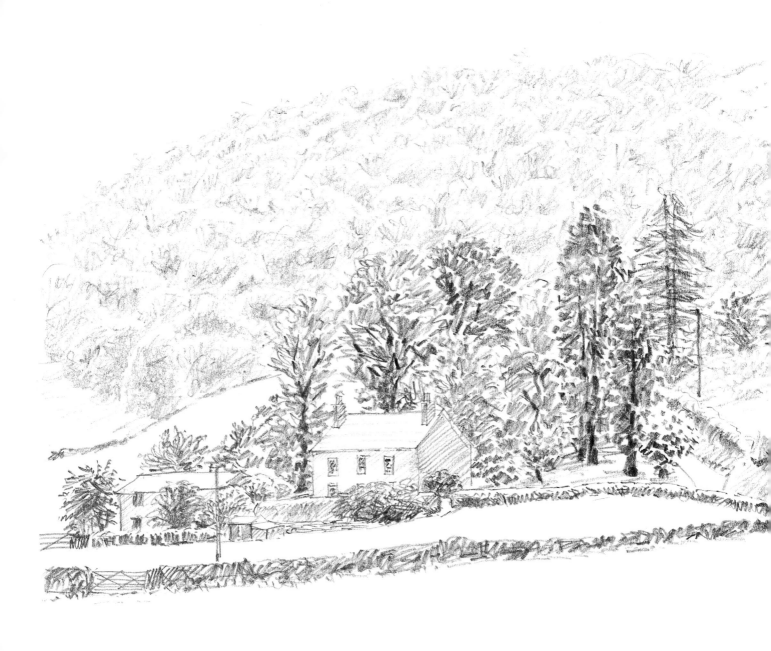

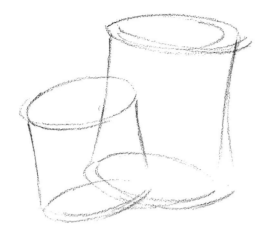

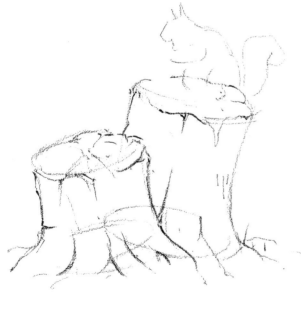

Using shapes in your sketches

Certain views and features may look daunting to sketch. Often, however, seemingly complex scenes break down into simple, easily drawn geometric shapes or solids. By ignoring all confusing surface detail and shading, you'll simplify the process of executing your sketch. Once you have a skeletal composition, with all its main parts in correct relative position and size, you can readily add detail and refine the basic lines of your structures.

The harbour sketched on the opposite page was, first of all, built up using a variety of shapes and forms. Boxes and prisms have been used for the buildings; pyramids, rhombuses, triangles and a crescent or two have gone into making up the quays and sea walls. The rocky headland in the background is a half-sphere which has been textured by using other shapes.

Rounded landforms can be simplified by geometric analysis. Steep-sided cones might form the basis of a mountain range, while foothills might be represented by half-spheres or cones with less steep sides.

I based this apparently complex tree stump (*right*) on two angled cylinders (*top*). Then I added more form and a squirrel (*above*) – note how even the roots can be seen as thin cylinders.
I used a 6B pencil and ink wash to shade and texture the finished picture (*right*)

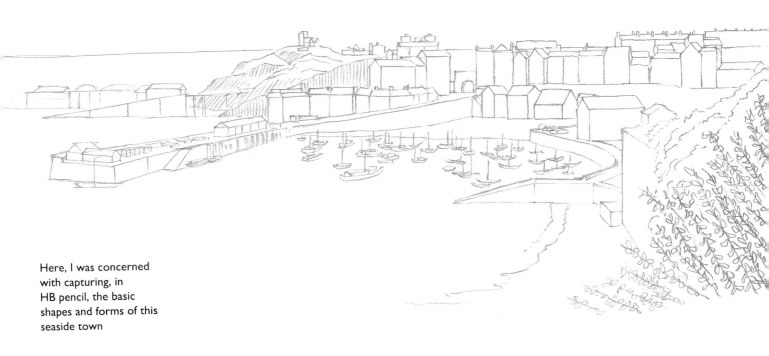

Here, I was concerned
with capturing, in
HB pencil, the basic
shapes and forms of this
seaside town

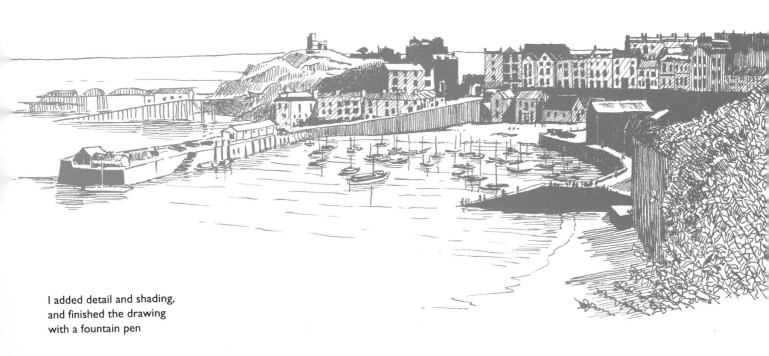

I added detail and shading,
and finished the drawing
with a fountain pen

Selecting a Subject

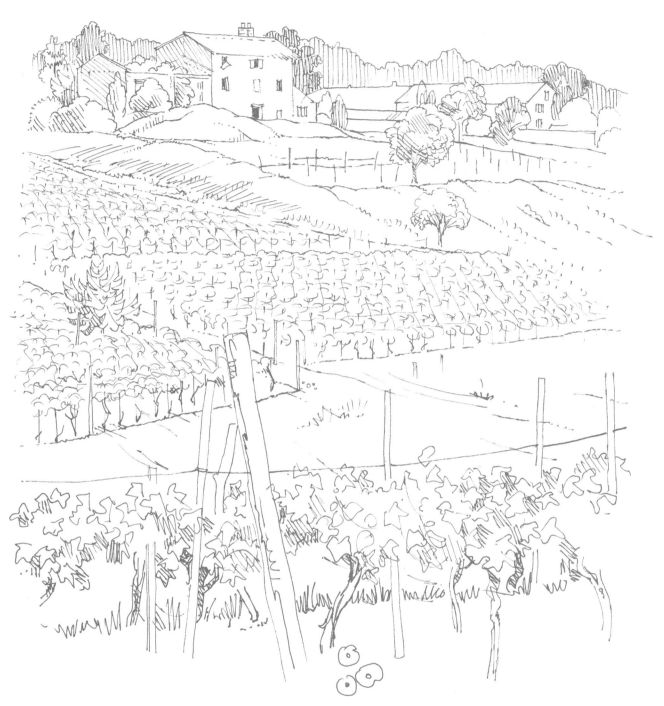

What do you draw?

Draw whatever inspires you – cascading water in a rocky ravine, rolling chalk downs or a garden on a summer day. Focusing on what inspires you will increase a drawing's impact. Without a planned focus in a drawing, you may waste time adding pointless and distracting detail. Use of greater detail, however, will highlight areas of interest once you have

Here, I decided to focus on the buildings of this vineyard. The darker background draws your eye towards the house and outbuildings

decided on the composition. Emphasizing parts of your picture works well both in black and white and in colour, where the use of not only greater detail, but also brighter colours surrounded by muted tones creates focus.

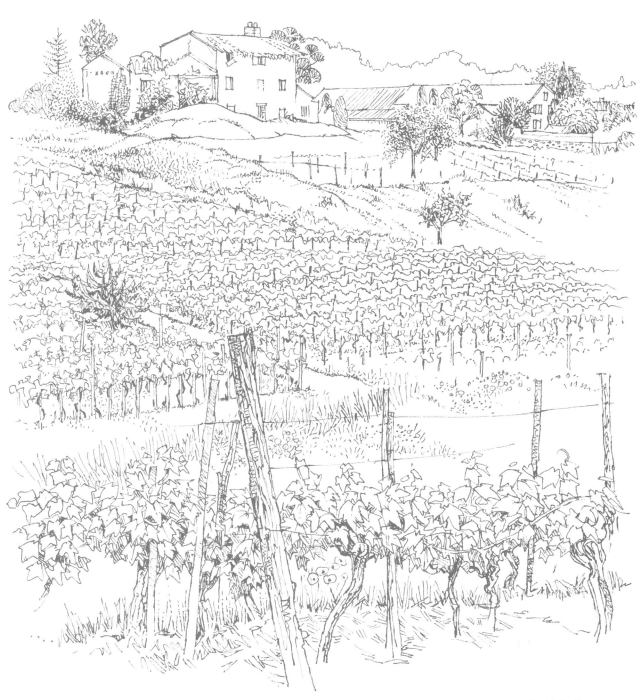

How much detail do you add?

Large areas of relatively empty space give a landscape an airy quality. Excess detail can create leaden lifelessness. Emphasize elements that best evoke the mood you want – just a few snowdrops visible in the foreground of a snowy scene, for instance, would convey spring's arrival. Eliminate anything that confuses your sketch or that detracts from the beauty of a

The focus was changed here by increasing the detail in the foreground and middle distance. The buildings are no less detailed than before

scene, such as a factory. Add details by referring to old sketchbooks. Copying old sketches of various relevant items into your landscape will enhance its atmosphere.

Framing and Composition

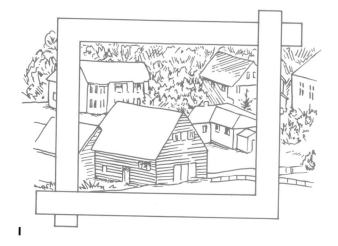

1

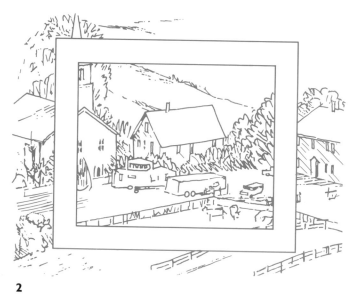

2

3

Choosing your composition

When you see a real landscape it registers as a composite of many images seen from different positions, each one reinforcing the others.

A drawing can't include *everything* you can see. Before you draw a landscape, look at it from different viewpoints to see which best encompasses the mood you're looking for. For example, a viewpoint that includes a gnarled, windswept tree in the foreground will emphasize the wild beauty of coastal headlands.

Choosing what to include

A composition can include as much or as little as you want. You may choose to draw a single tree in detail. You may, on the other hand, choose to focus on two elements, such as a building and a pair of trees. A more ambitious composition could include a variety of objects normally found in a country landscape, as shown in the drawing opposite.

Link the elements of your composition – unrelated shapes scattered across a landscape can appear disjointed, providing no single focus for the eye. Try to vary the size of elements in a picture – a sky filled with rows of evenly spaced clouds of the same size will look boring.

Framing the scene

At first, you'll often have problems isolating the best parts of a complex landscape to form a good composition. In fact, one large view often provides a variety of smaller compositions. To facilitate isolating smaller parts of a scene, look through a frame. This will help you to compose different compositions, eliminate extraneous detail and focus your thoughts. You can make one by holding two L-shaped pieces of card together (**1**). Alternatively, you could use a card frame that is the same size as your paper (**2**). If you prefer, form a frame with the thumb and forefinger of each hand (**3**). Try plenty of alternatives and make some rough sketches of different compositions before making a choice.

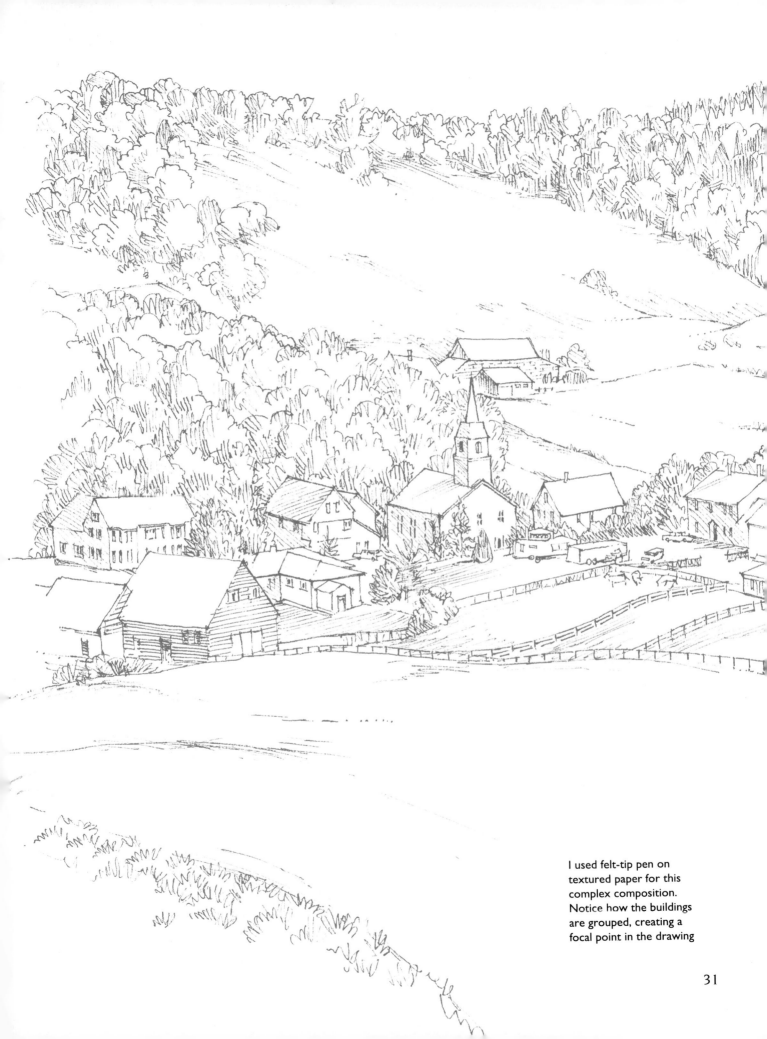

I used felt-tip pen on
textured paper for this
complex composition.
Notice how the buildings
are grouped, creating a
focal point in the drawing

Drawing Trees

Single trees or vast forests lend a sense of time to a landscape. Deciduous trees are the best seasonal indicators. Blossom-laden branches denote spring; but in summer, foliage is much more lush. Falling autumn leaves partly expose branch structures and carpet the ground. Finally, winter reveals a tree's skeleton.

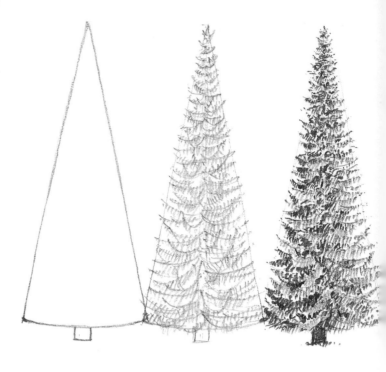

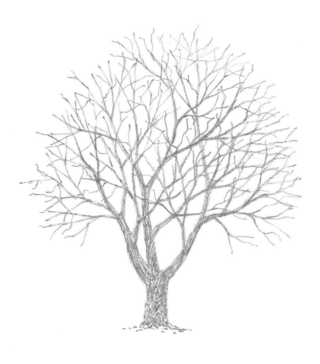

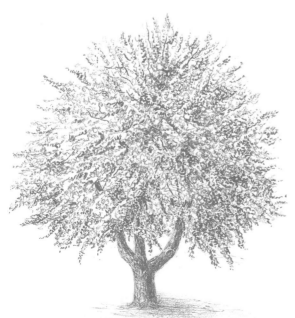

I drew this deciduous plum tree (*left*) both in winter and in spring to show how its irregular form becomes more regular when in full blossom

The conifers above were drawn using basic shapes to illustrate their general, regular form. Those that are pictured in detail were sketched in B and 2B pencil

Basic tree shapes

Understanding their basic shapes and patterns of growth can help you to draw trees. Thin, tall conifers, such as firs, often have a symmetrical conical shape. Their twig-bearing branches emerge at regular angles from the trunk. Deciduous trees are shorter in relation to the girth of their branch structure. Their branches divide many times into successively smaller ones that finally end in leaf-bearing twigs, creating less regular shapes.

Gaps between branches are fairly obvious in the foreground; as you move away from a leafy tree, outlines fill in and gaps become less apparent. When drawing a large group of trees that recedes into the distance, make use of this visual quality to give your drawing depth.

Branches, volume and depth

Branches enclose a vast amount of space. If you forget this, you'll draw flat, lifeless trees. Observant handling of the play of light and shade within a branch structure will help create a sense of volume and depth. A branch's cast shadow will briefly cross branches behind it, curving round their forms to create space within the structure and add form to single branches. Foliage can cast shadows on the trunk and branches immediately below it. Don't forget the shadow a tree casts on the ground!

You'll learn a lot about tree structures by regularly working in your sketchbook. Try drawing the same tree at various times of the year and from different positions.

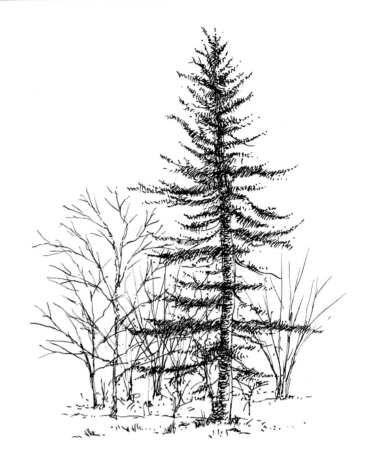

The maple trees below were drawn in winter using pen. Note how the nearest tree is the most detailed one

The spaces between the branches of the conifer in the foreground of this sketch of a copse (*right*) add depth and volume

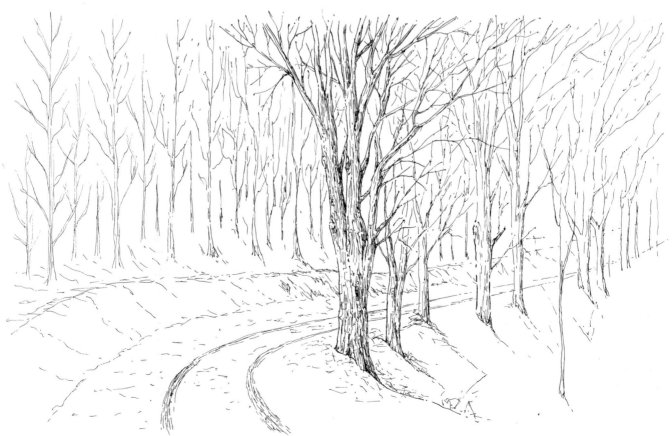

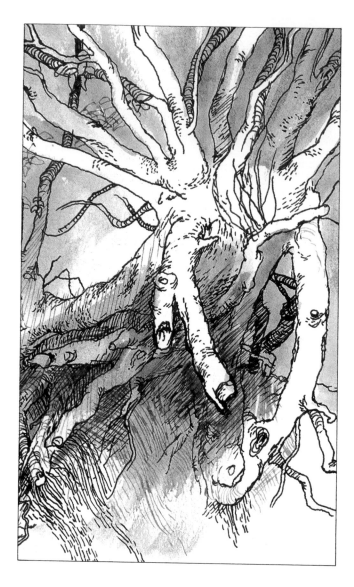

Environment and growth

Habitats determine the species that grow in them, and may affect the growth of individual trees – for example, exposed trees are often bent or stunted by strong prevailing winds. Tropical swamps and wetlands are homes to trees that thrive in or near water. Trees by rivers often lean steeply towards them, if the water is eroding the river bank on which they grow. Trees by calm water have mirror-like reflections; the reflections of those by choppy water are more distorted.

I used consistent, curving, HB-pencil strokes to echo the regular shape of these mountain conifers (*below*). White space conveys a blanket of snow

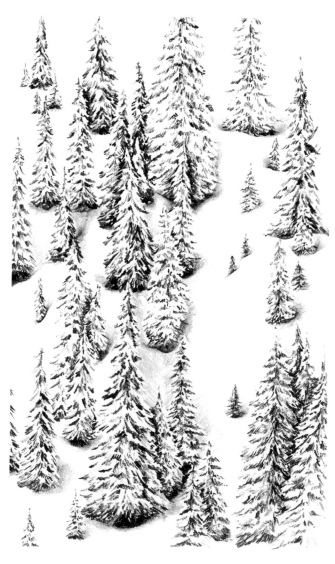

Old, fallen trees and exposed roots provide an opportunity to study how shapes and textures lend character. The picture above was drawn in pen and an ink wash was added with a brush

Bark textures and tree age

Sketchbook close-ups of various types of bark – from smooth silver birch to craggy oak – are useful for reference. Most kinds of bark become rougher with age. Deciduous trees' trunks and branches twist and turn more as they get older.

Leaf shapes vary a lot but usually have a symmetrical, bilateral form. Note where leaves branch off a twig – do they alternate from left to right along it or do they have a common source?

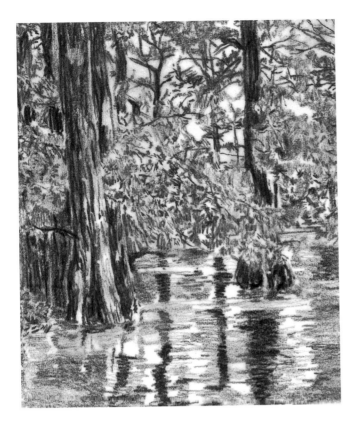

Groups of trees

Practise sketching small tree clumps, where separate shapes can be clearly seen, before you try larger tracts of trees. Sketch a group from various positions and at different times of the day or year. Different species with distinctive shapes in nearby groups can be depicted simply with shading, or you can stipple and use lines or a pattern to add leaf textures. Colour and texture of contrasting trees seen further away may be shown as juxtaposed areas of light tones on darker ones. Silhouettes or simple vertical shading of varying height can represent trees seen in the far distance.

Try to draw rows or avenues of similar trees to explore some of the effects of perspective.

A 2B pencil was used on tracing paper to draw these swampland trees and their calm, watery reflections

I drew this clump of trees on a winter's day with a technical pen on smooth cartridge paper

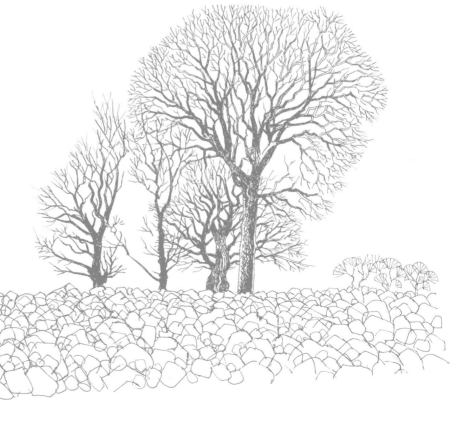

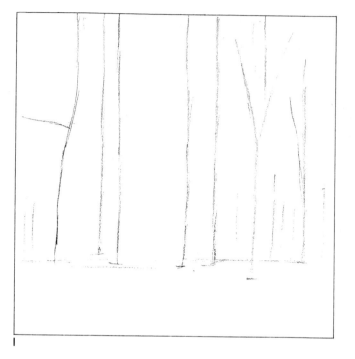

1

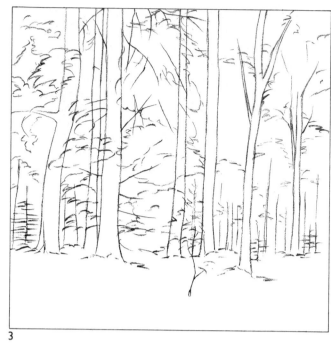

3

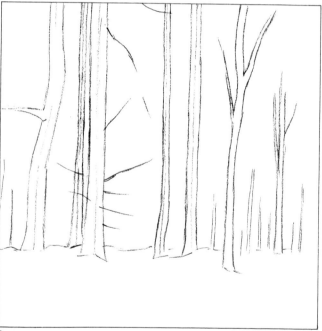

2

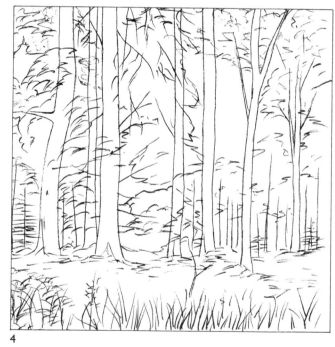

4

A woodland interior provides a challenging but satisfying chance to explore many textures. You can simplify the task by reducing it to easy stages. When you've composed a view and chosen a focus, lightly sketch rough verticals for the main trees (**1**). Now add the main horizontal outlines and refine the tree shapes (**2**). Once you've done that, begin to sketch in features in the background (**3**). Follow this with foreground detail such as flowers or shrubs (**4**). Finally, when you've outlined all the elements you need, add surface detail and texture, shading forms to give volume (**5**). Always leave fine detail until last, otherwise it might confuse you as you try to sketch in accurately the positions and proportions of the main elements.

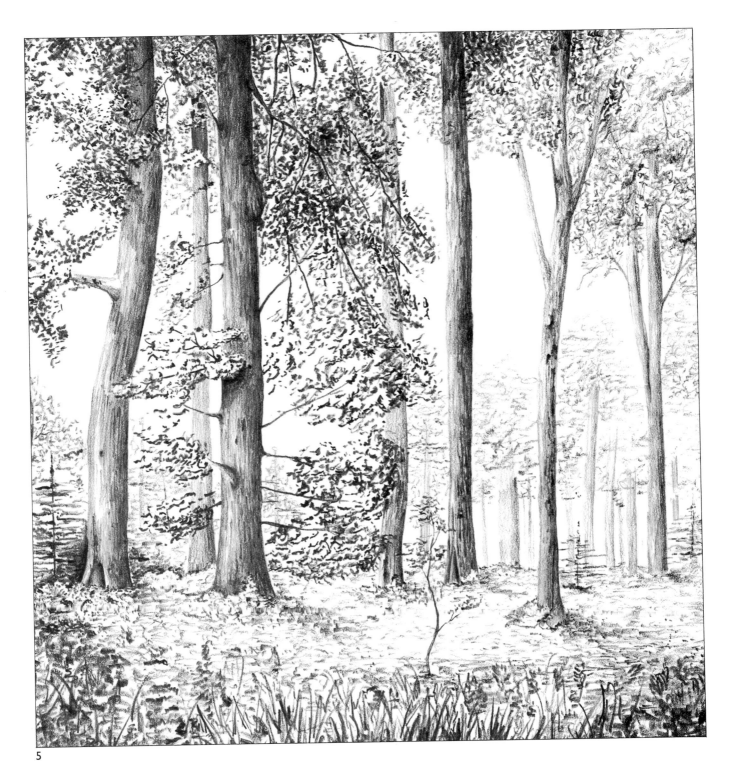

5

Careful use of light and shade is vital for the feel of dappled woodland light. Remember to draw foreground objects in darker tones and more detail than distant ones; eliminate some distant trees if it helps to add an airy feel.

My final drawing was done in 2B pencil on cartridge paper. I left out some trees to avoid background clutter

Drawing Skies

Weather and atmosphere

Sky, in a landscape, adds atmosphere and tells us about the weather. Dark shading drawn at a uniform angle from sky to land suggests distant falling rain. Vigorous strokes in the sky give the appearance of wind, which can be reinforced by bent tree branches. Mist obscures parts of a landscape and diffuses sunlight to render objects as flat, hazy shapes of limited mid-grey tones and weak shadows.

A sky is palest at the horizon and darkest at its zenith, and is usually lighter than the landscape. Avoid creating overwhelmingly dark skies.

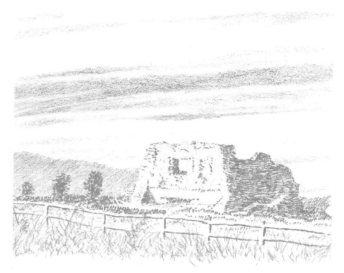

The dark 2B-pencil strokes on rough paper below portray dark skies that suggest the impending possibility of heavy rain and high winds

I used light HB-pencil strokes to depict the flat clouds that adorned the peaceful summer's sky in this sketch of country ruins (*above*)

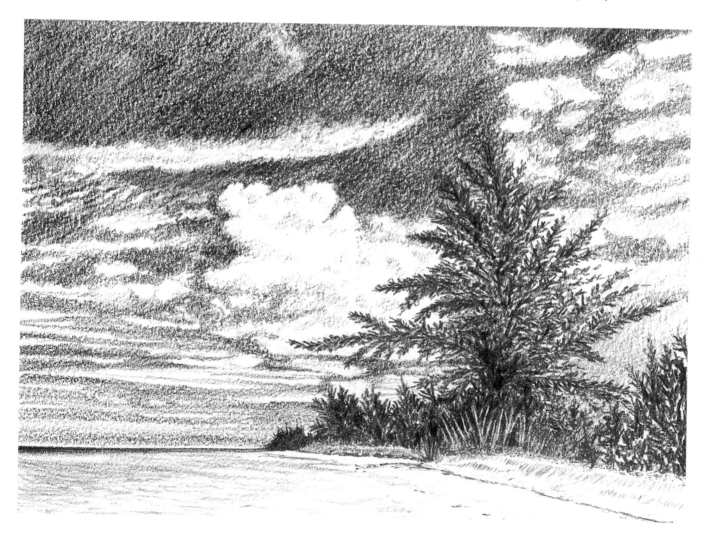

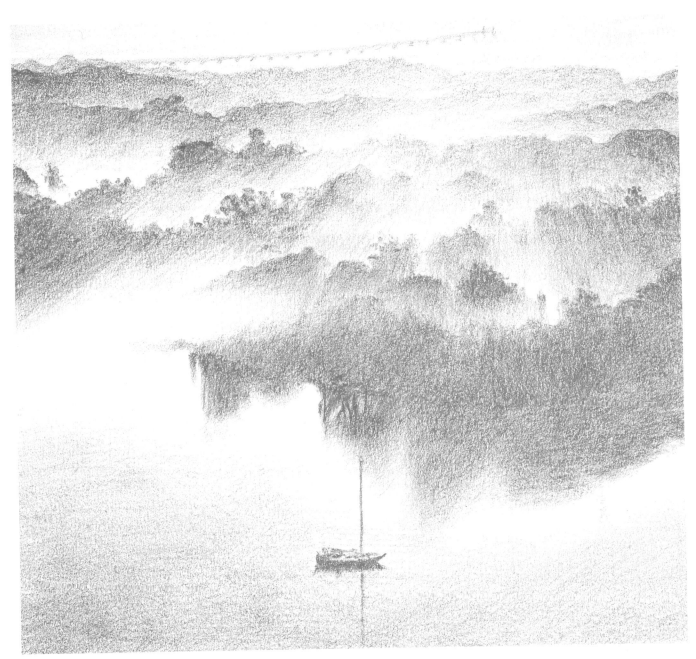

Clouds, light and shadow

An illustrated book on weather will help you to practise sketching various types of cloud. When depicting a real scene, clouds rapidly change, so work quickly. Treat them like solid objects on land; start with outlines and add detail last. Remember that light falls on clouds from one direction, and that size and textural or tonal values diminish with perspective. Use simplified shading of just a mid- and a light grey – pure white paper can indicate luminous light. For a

From a hilltop nearby, I used a B pencil on stationery paper to capture the effect of this sunrise on a misty lakeside forest

feeling of lightness, don't overwork the shading. A landscape echoes its sky. Light strikes the ground through cloud breaks and clouds cast shadows on the land – remember to vary shadow strengths to match different cloud densities.

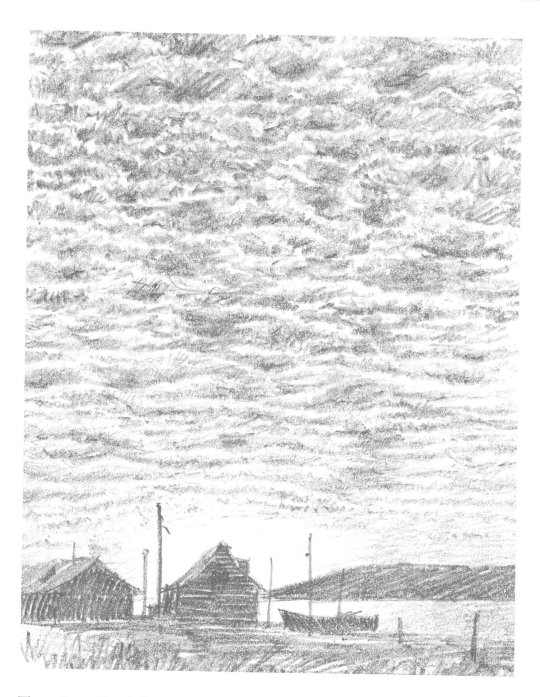

The light and dark strokes of a B pencil show a mackerel sky highlighted by a sunset over these lakeside lodges (*left*)

The colour of and the quality of light from the sky are very important in the way they influence the appearance of a landscape. Light and shade affect objects on the ground (see p. 18) and clouds in much the same way.

If features in the landscape stand out against the sky, they will have a different appearance depending on whether the sky is light or dark. This is because the balance of contrasts alters.

Sunrises and sunsets

Sunrises and sunsets can be very dramatic, with strong tonal gradations between the dying light of day, on the horizon, and dark night tones higher in the sky. The brightest light may appear above the sun, not around it. Draw elements that are close to you in subdued detail and limited tonal ranges to help you effectively represent dawn or dusk. Objects further away will be in silhouette.

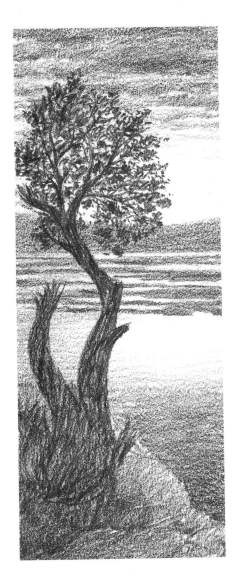

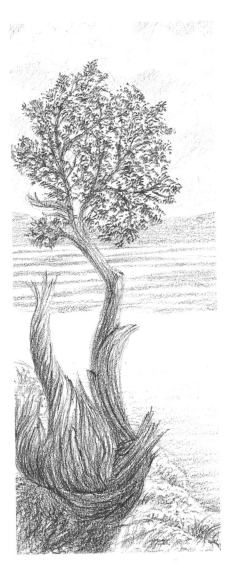

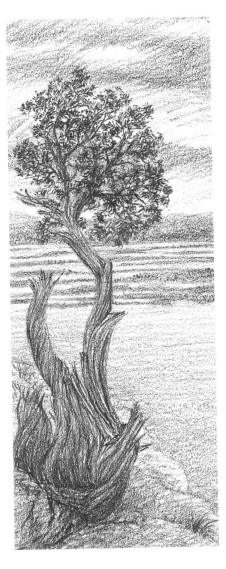

In the drawing of a sunrise over a river above, the strong silhouette in the foreground adds depth

At midday, the same scene above is brightly lit by the sun, so more detail and a lighter tonal range were used

This drawing of the river on a dull day (*above*) required more greys and fewer light and dark tones to convey the gloom

Studying different types of light

Practise sketching the same view at various times of the day and night to study different types of light. You can sketch a local spot in various weather conditions through the year. Note how sky colour and cloud formations affect the landscape. You can work at home, using your own photos for reference, but there's no substitute for open-air sketching – even if it's freezing outside!

Drawing Water

Water in a landscape – puddles and lakes, rivers and waterfalls, or waves crashing on to a beach – adds a fascinating focus. But you can't draw water itself – what you actually draw is usually light reflected on its surface.

Mirror-like reflections

Perspective plays an important part in depicting water. If trees, such as those shown below, are viewed at the water's surface level, their reflections will have dimensions similar to the trees themselves. If your eye-level were raised, you would see a foreshortened reflection – less of the trees would be visible in the water. Allow for the fact that the reflection of an object such as a boulder set back on a river bank (*right*) is interrupted by the bank and its own reflection.

The swampland trees below were drawn in HB pencil on textured paper.

The reflections were broken up by erasing the marks in some places

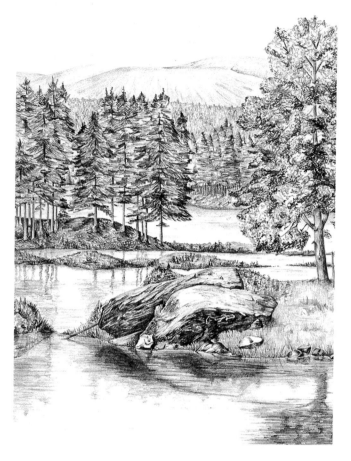

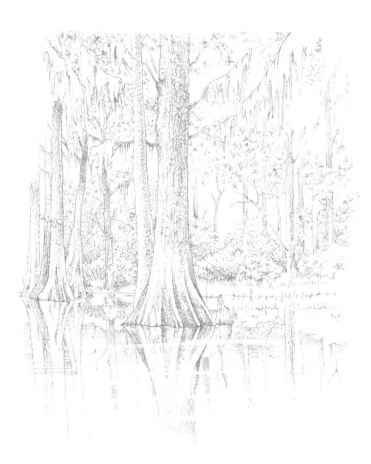

In the drawing above, I conveyed the steady, even current of this river by breaking up the reflections with short, parallel B-pencil strokes

Broken reflections

Ripples 'slice up' reflections, displacing the slices and leaving gaps between them (*left*). A tree's reflection in gentle ripples can still be recognized, but increased rippling would fragment it into abstract patches of colour.

You can depict broken reflections in one of two ways. You can draw a clear, mirror-like image, and then break it up by rubbing out the pencil marks with the sharp edge of a rubber, as in the drawing on the left. Alternatively, the general shapes of the objects reflected can be shaded using short, broken, parallel lines, as in the drawing above – the edges of the reflections are indistinct, conveying the ripples on the water.

Water in shadow

When you see water in shadow, it acquires a transparent appearance. In the drawing below, you can see through the water to the stones at the bottom of the lake. This is only true, though, in shallow water. Large bodies of deep water in shadow will appear dark and gloomy.

The nature of water

Quick sketching, previous observations and an awareness of the forces at work on water can help you to capture its free form. You can watch water in motion by filling a bath – look at how water flows and spreads over the bottom, how it twists as it falls, the way it hits the water surface, and how it runs away as the bath empties. The lessons you learn from sketching these effects may be invaluable for open-air work.

Here, you can see how light and shade affect the transparency of water. I could see the bottom of this lake where the water was in shadow

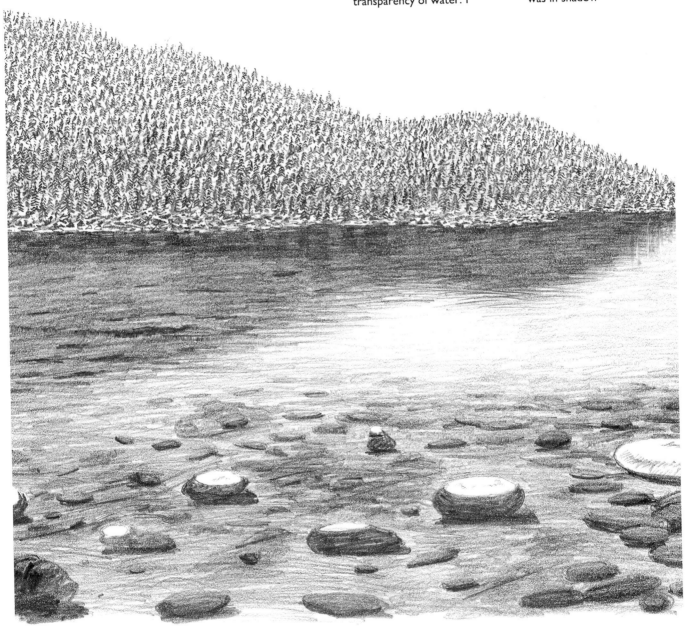

Movement

Water surfaces are animated by a complex mix of winds, currents and turbulence (created as water flows over a river bed). Currents and winds running in the same direction generate parallel waves, but create irregular, choppy ones when they are opposed. You need to be able to illustrate the sluggishness of a slow river or lake current as well as the power of ocean waves.

The ripples or small waves on the surface of a lake or stream indicate the direction of the current. These can be conveyed by using short, parallel strokes. Alternatively, if you need to show the movement of a fast-flowing river or waterfall, you should use longer, freer strokes.

To illustrate waves at sea, use horizontal, undulating lines to represent the crests of the waves. Remember that perspective comes in to play. The vertical spaces between the crests become more narrow as they recede into the distance. Don't forget that bodies of water reflect the colour of the sky and nearby landforms.

Short strokes were used for the calm sea below. Curved strokes form the breakers. Undulating lines of stippling mark the extent of the sea foam

Dark and light 2B-pencil strokes gave the contrast needed to show the light reflecting off these waves breaking on cliffs (*below*)

Long, flowing lines, made with an HB pencil on textured paper, capture the movement of these waterfalls (*opposite*)

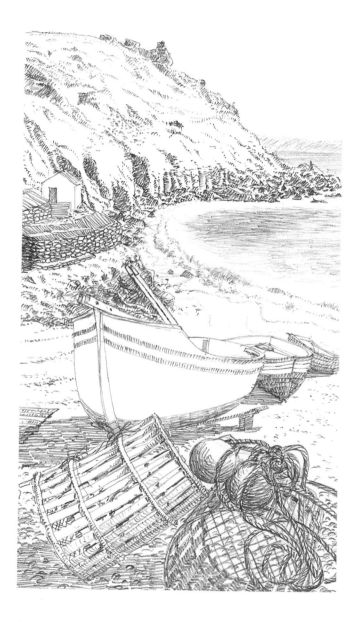

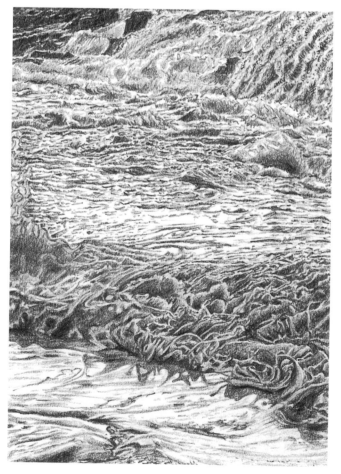

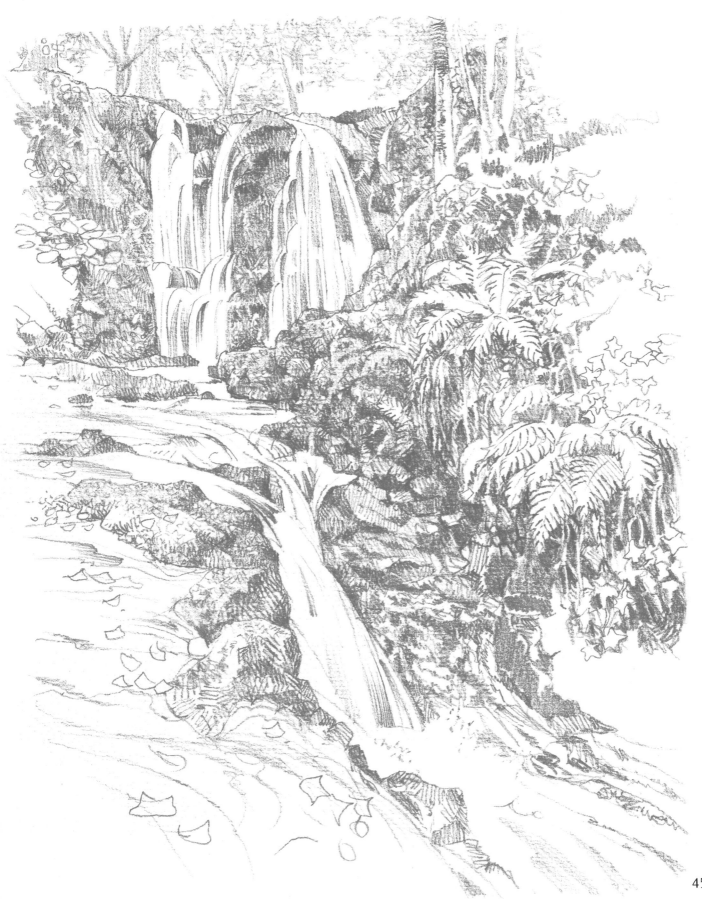

Buildings in the Landscape

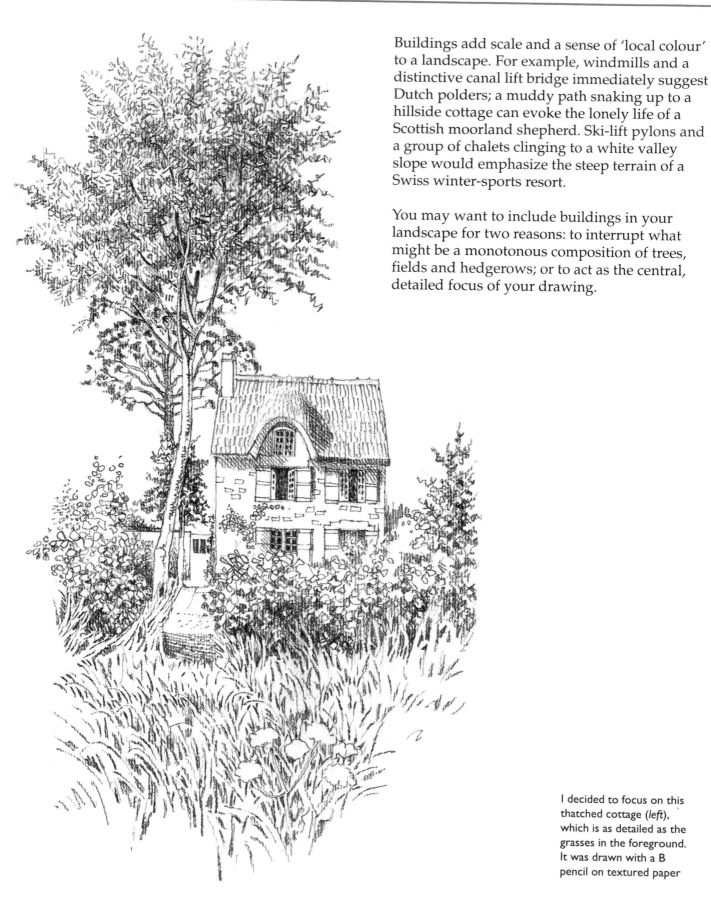

Buildings add scale and a sense of 'local colour' to a landscape. For example, windmills and a distinctive canal lift bridge immediately suggest Dutch polders; a muddy path snaking up to a hillside cottage can evoke the lonely life of a Scottish moorland shepherd. Ski-lift pylons and a group of chalets clinging to a white valley slope would emphasize the steep terrain of a Swiss winter-sports resort.

You may want to include buildings in your landscape for two reasons: to interrupt what might be a monotonous composition of trees, fields and hedgerows; or to act as the central, detailed focus of your drawing.

I decided to focus on this thatched cottage (*left*), which is as detailed as the grasses in the foreground. It was drawn with a B pencil on textured paper

These farm buildings (*left*), set in bleak hill country, were drawn in felt-tip pen on layout paper

I drew the farm-workers' cottages above in early spring, using thin felt-tip pen on rough paper

Suggesting shape and form

You may prefer, however, to devote your artistic efforts to portraying the surrounding countryside, rather than the buildings in it. If so, it is probably a good idea to depict the latter by merely suggesting their shape and form, without concentrating too much on texture and detail.

Images of the landscape

Buildings are the focal points of the drawings shown on these pages. They tell us something about the landscape in which they are set. The drawing of the cottage opposite presents the countryside as a lush, idyllic place. The study on the left, however, depicts the sturdy, functional buildings of harsh, hill-farm country.

Using basic shapes and solid forms

You may be put off drawing buildings because of difficult angles and distortions of perspective. Most buildings, however, can be broken down into a series of basic shapes, such as rectangles, squares, triangles or circles, and solid forms, such as boxes, prisms, pyramids or cylinders.

In the drawing opposite, I reduced the buildings to basic block shapes, trying to obtain the correct proportions and angles, before going on to add chimney stacks, windows and doorways.

You need to remember the surroundings in which a building is set. These are important as they help to portray, say, the tranquillity of a tiny cottage in the middle of nowhere, or the hard work put into the land around a farm building.

Once you've added the basic elements of the surroundings, you can go on to think about light, shade and texture, and how much final detail you wish to add. Tackle these stages with care. It is very easy to spoil a drawing, at this stage, by overworking it or mistaking the direction from which the light is coming.

Remember that objects become lighter and less detailed the further away they are.

I began drawing the farm buildings below using simple lines in pencil to put in block shapes. I was not concerned with detail. I then went on to add the foreground features, surrounding detail, and the windows and chimneys of the main building

I used HB and 2B pencil on textured watercolour paper for the final drawing opposite

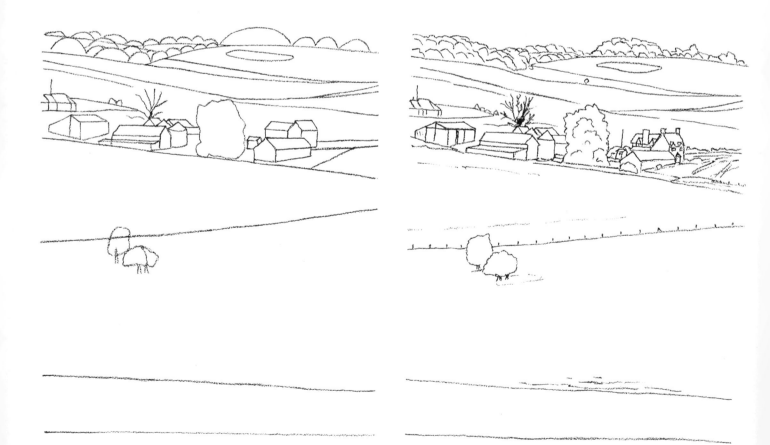

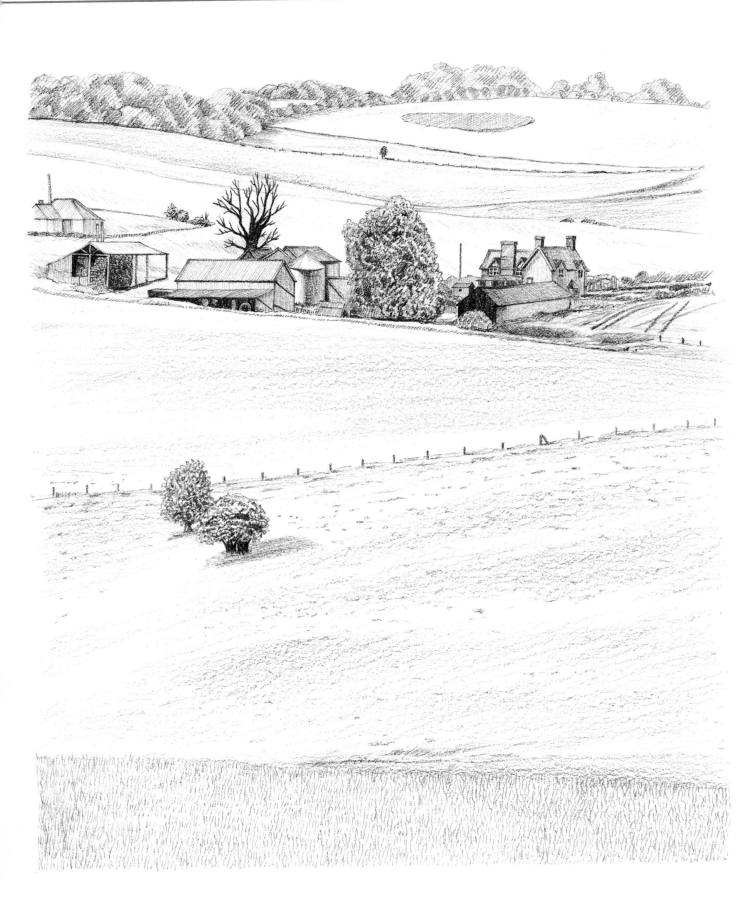

Plants and Flowers

Woodland spring bluebells, red poppies in a summer field, or a hedgerow of red, orange and black autumn berries and seeds add interesting seasonal clues to pictures. Drawing from life ensures a plant has a natural location, but remember, when adding pictures of plants from a sketchbook, to check that you are placing them in the right kind of habitat.

Studying shape and form

Realistic drawing comes from keen observation. Like trees, plant structures – leaves, stalks and flowers – have volume; note how light and shade play on and inside these structures when you begin drawing. Look at the parts of a plant. Most leaves have a bilateral symmetry divided by a central vein; but are they long and thin or teardrop shaped? Are the edges serrated, wavy

This carpet of 'dame's lockets' (*below*) conveys lush springtime growth in lakeland woods

From a low eye-level, I isolated this plant (*right*) and drew it in great detail against the sky

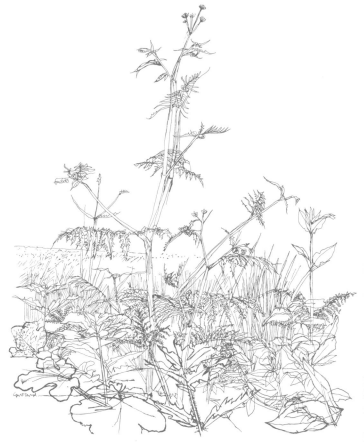

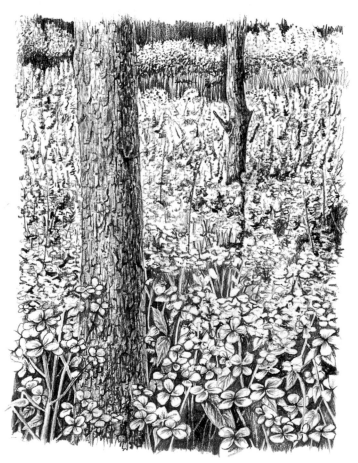

or smooth and are the tips pointed or rounded? Where do leaf stalks branch off the main stem? Many alternate from left to right at regular intervals, but others join in clusters of two, three or more at the same spot. If there are thorns, look for a pattern to their arrangement.

A study of plants soon reveals the importance of spiral forms, from spiral clusters of sunflower seeds to clinging honeysuckle stems. When seen from above, leaves often spiral round a stem to maximize the plant's absorption of sunlight. But don't draw plants as if assembling kit parts or you'll only create lifeless forms. Try to sketch the main forms of a plant in flowing, organic lines, adding detail later.

Practise sketching pot plants at home. A useful exercise is to sketch cut flowers at various stages in their decline, noting changes in form and texture. You can enliven a landscape by mixing living plants with dead or dying ones.

I used a fine ball-point pen
to sketch these poppies
on a hillside

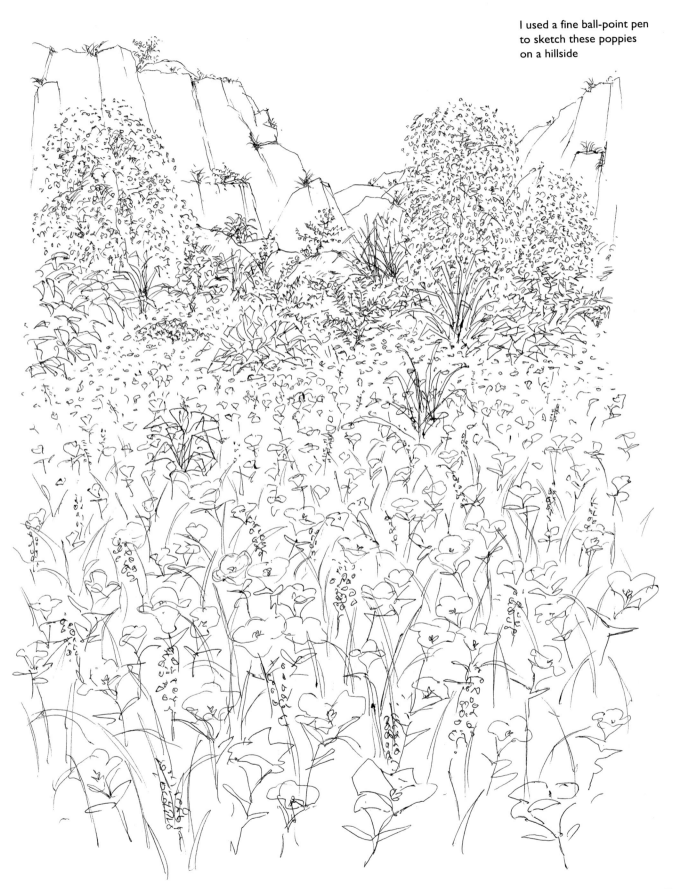

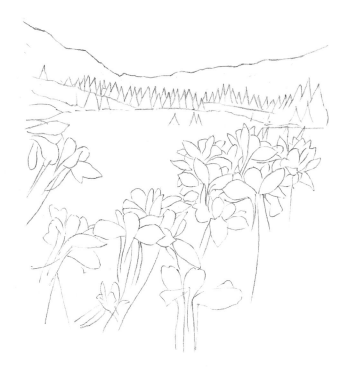

Large expanses of flowers

If you draw plants in large expanses, it is best to draw those nearest in more detail and darker than those further away, which should be seen as a mass receding into the distance. The 'dame's lockets' on p. 50 have been represented thus. In this respect, regular rows of cultivated plants are easier to draw than masses of wild plants. To give depth to such drawings, it is always good to have a few plants and flowers looming large in the foreground, as in the drawing opposite. In this way, the viewer will have an idea of how those further away are supposed to look in terms of detail and texture.

If your focus is on flowers in the foreground, sketch them in first, then look for the main lines of form or shape in your subject to help you in your composition. Add background detail lightly, using perspective and the relative positions of objects to create a sense of volume and depth. Add texture, shading and detail only when you are happy with your initial sketches.

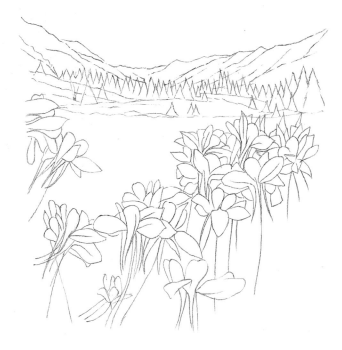

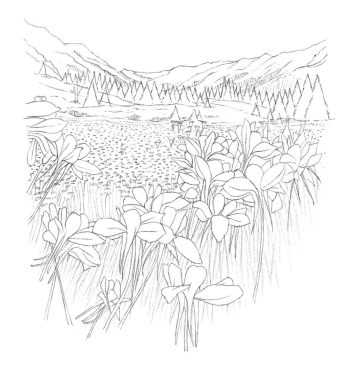

I began by sketching in the main features of my composition (*top*), with an HB pencil

I went on to outline the valley, trees and mountainsides in faint strokes (*above*)

I began to flesh out the sketch by adding light detail to the receding expanse of flowers (*above*)

Darker tones, textures, and final details were added in 2B pencil to complete the drawing opposite

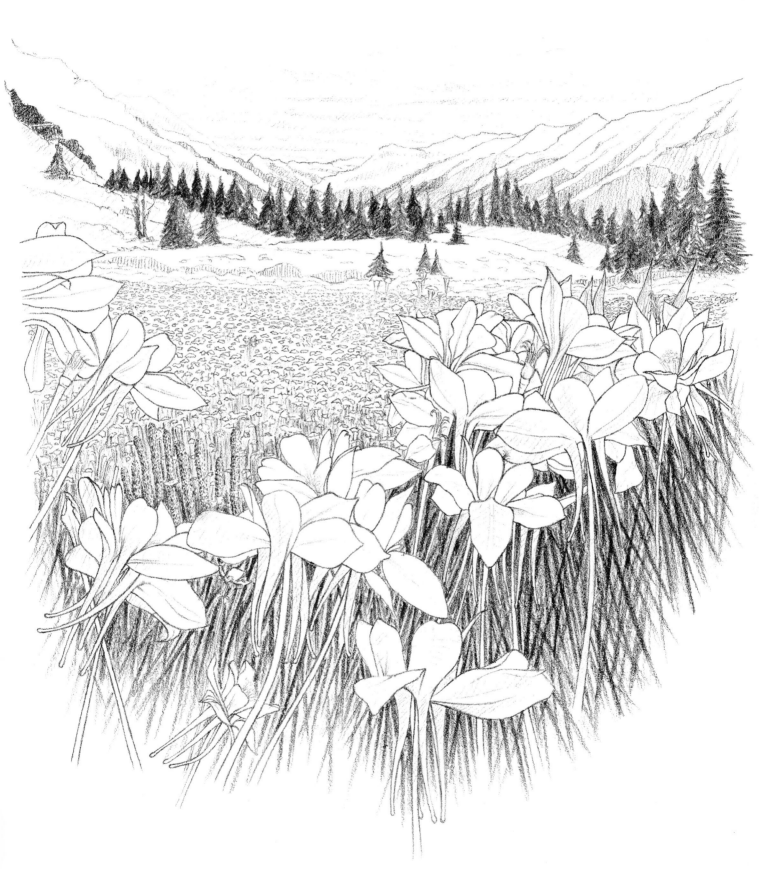

Country Wildlife

A nervous deer scenting danger, a stealthy otter hunting fish on a river bank, or any other active animal will enliven your landscapes.

Keen observation and sketching practice will help you master the problem of drawing moving animals. You can begin by copying photographs. Your work may not be spontaneous, but you'll gain an eye for anatomy. The next stage could be to draw a pet, starting with characteristic sleeping positions and then going on to try to portray the pet as it moves about. You may not want a cat or dog in your landscapes, but you'll learn to observe movement and capture its fleeting nature with a few rapid, economical strokes. Slow-moving farm animals are also good subjects for practice.

The rapid 4B-pencil sketch below captures the typical look of a shy otter

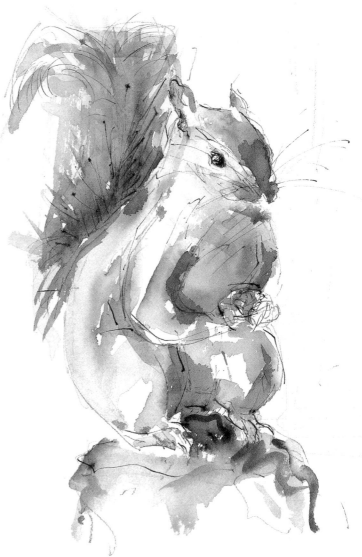

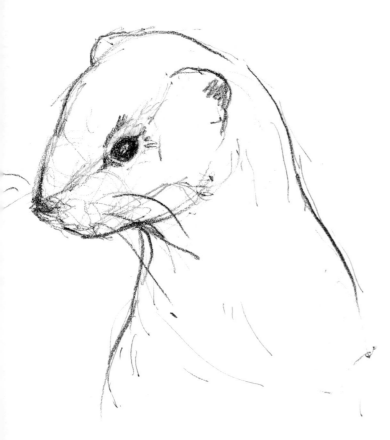

Working with less speed in watercolour and dip pen, I made this sketch of a squirrel (*above*)

Concentrate on one type of animal at first, so that you can familiarize yourself with its anatomy and how it moves. It's normal to have unfinished sketches because the animal moved, so don't let that worry you. Make lots of studies of details, such as ears and eyes, as well as more complete drawings of animals. Soon, you'll gain enough confidence and skills to be able to visit a zoo and return with a bulging sketchbook.

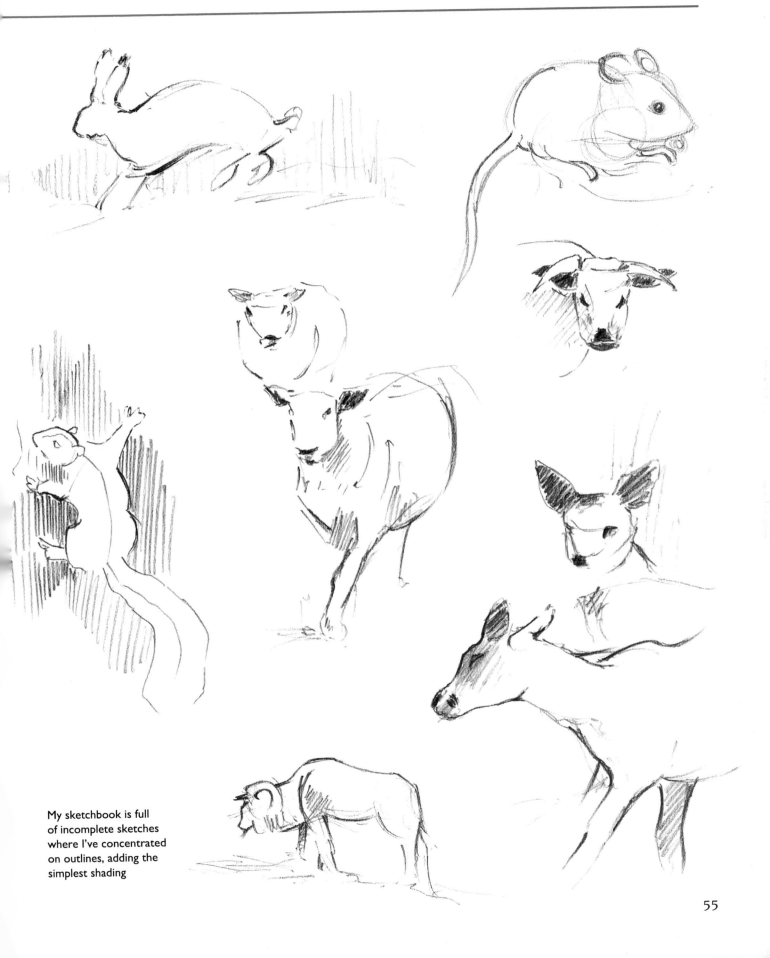

My sketchbook is full of incomplete sketches where I've concentrated on outlines, adding the simplest shading

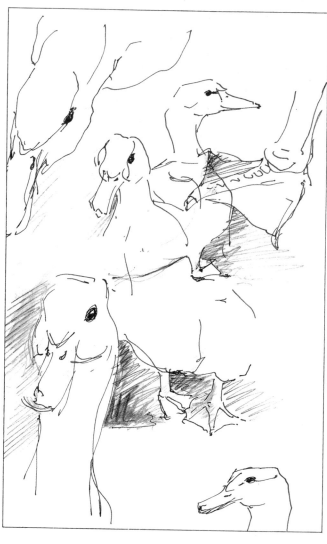

I used dip pen and ink to draw characteristic details of duck poses in my sketchbook (*above*)

Drawing birds

Every habitat has its own unique bird population. Wetlands are home to reed warblers, ducks and long-legged waders. Rivers attract dippers, swans or kingfishers. Game birds, such as grouse or pheasants, are better suited to rough moorland. Woodlands abound with blue tits, blackbirds, woodcocks, jays and owls. Coasts support gulls and other sea birds.

Many birds migrate to breed or find food at different seasons. Seagulls, for example, make incongruous inland visitors when winter coastal conditions are too arduous for survival.

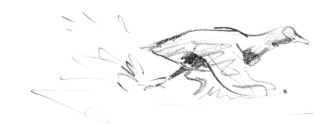

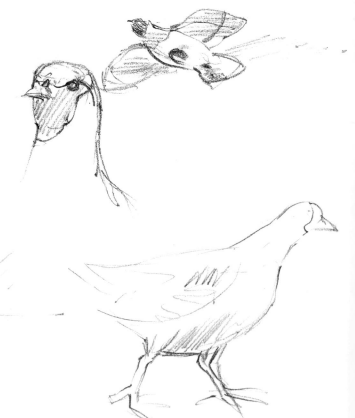

These coots and the study of a partridge in flight, including a close-up of its head, come from my sketchbook. They were drawn in soft pencil, which is best if you need to work quickly

Birds take flight at the least noise and can be even harder to draw than animals. The exercises that helped you to draw animals (*see p. 54*) can be applied to birds – try sketching by a park lake where birds are more used to humans and less likely to be scared off. Your sketchbook will become an invaluable source of ideas, full of studies and characteristic poses that can be used in larger drawings. Be careful about placing birds in landscapes – adding a sketch of a river bird to a moorland scene would be incorrect!

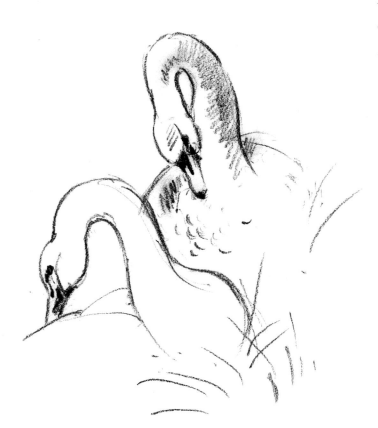

These are two of dozens of 6B-pencil studies I made of the sinuous necks of preening swans in my local park (*left*)

I sketched the Canada goose (*below*), standing by the water's edge in marshland reeds, in 4B pencil on cartridge paper

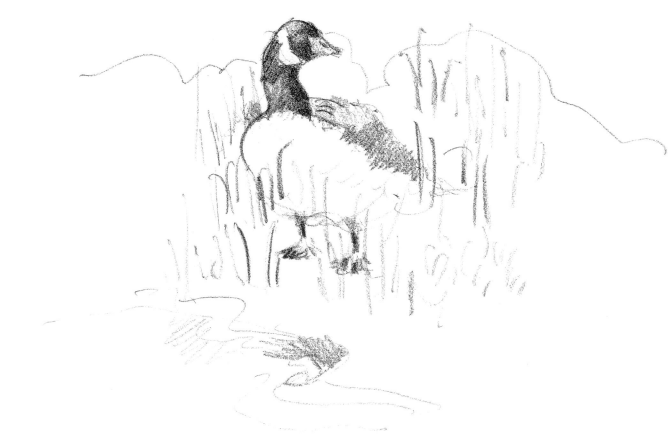

People in the Landscape

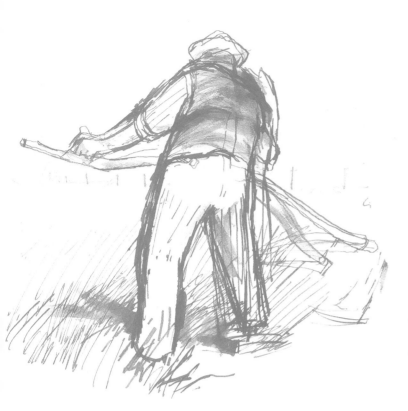

We naturally empathize with people in a drawing. However far away they appear to be, they provide scale and add dynamic movement to any landscape. Like animals and birds, people don't stand still for long, so you need to learn to work rapidly to catch the fleeting essence of movement. Observe and draw what you see – don't invent or draw what you think you know; practice will help you to freeze movement in your memory after a subject moves away. Try not to be too conspicuous when you sketch – you're unlikely to frighten people away but you can make them self-conscious, causing them to adopt stiff, unnatural poses.

Whenever possible, I use my sketchbook to note figures which may be useful to add to any compositions that I might create at a future date. Usually, I begin by capturing the essence of a pose; then, if possible, I add detail at a later stage

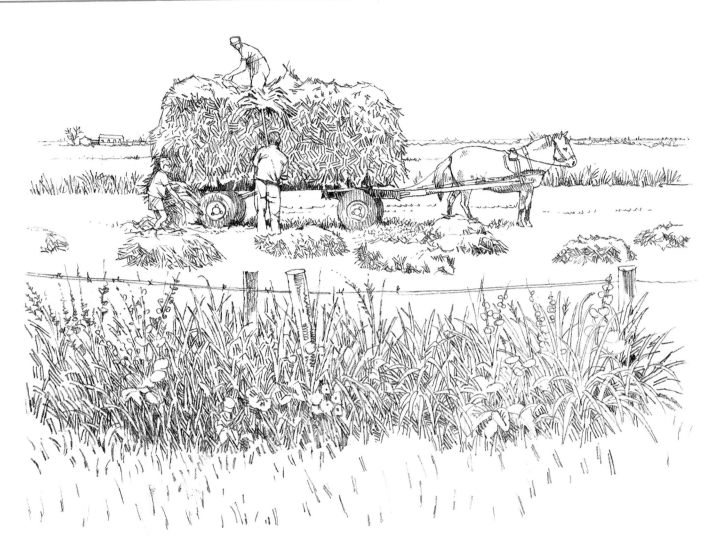

Using an H pencil on layout paper, I drew this scene of the countryside at harvest time. I decided to animate it with people gathering hay

Movement and proportions

You can practise sketching people anywhere – urban studies in a sketchbook easily transpose to a rural landscape. Observe how people walk or run, how they pull or carry heavy loads, and how they relax when they sit down. Try to capture characteristic movements of people at work – the gestures of a farm labourer making hay or herding cows.

Contrast the slow, perhaps painful gait of old people with the sprightly movement of children at play; don't forget that children are not miniature adults – their heads are larger relative to their bodies when compared with the adult physique. Concentrate on capturing body forms and the movement of limbs; facial detail and clothes are less important in landscapes.

Crowds and perspective

Human interest in a landscape can be provided by one or two solitary figures. But you may want to show groups. If so, you'll need to include space around the figures to create a sense of volume and depth. Even people huddled in a tightly packed crowd need space around them – watch how figures overlap and hide the forms of those adjacent to them, and cast shadows on each other. Light should fall on all figures from the same direction. People in the background should appear to be smaller than those in the foreground.

Working from Photographs

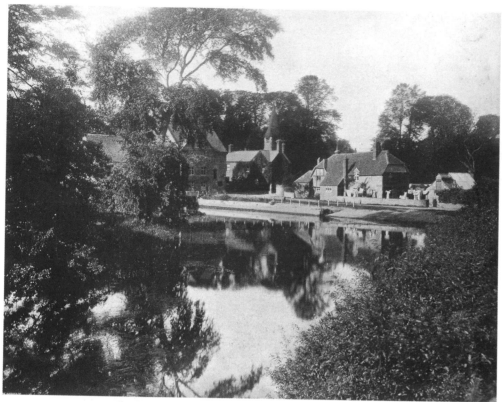

I picked this photograph (*left*) from an old, Victorian album I have which is a good source of pictorial reference

You can increase your drawing confidence by drawing moving elements – clouds, water or living creatures – from photographs. Many professionals base whole compositions on magazine photographs, their own snapshots or postcards, so don't be embarrassed to work this way at home, where you can work at leisure with a wider range of tools.

Your camera can be as useful as a sketchbook, but don't slavishly copy your photographs – the results will be stiff and can never match the detail of an original. Try to interpret a photograph to create your own landscape.

One way to alter a photograph is to draw only lines, without shading. Bold effects are created by reducing wide photographic tonal ranges to black or white, with no intermediate greys.

Changing the **contrast** or lighting effects in a photograph will alter a picture's mood. Take care (if you alter the sun's position) that light and shade on forms in your drawing are always consistent with the direction from which the light is coming.

Recompose photographs or combine several for the result you want – simple additions or deletions of various elements often radically change compositions.

To increase the variety of possible compositions and recompositions, it would be a good idea for you to take as many photographs from as many different angles and viewpoints as you can.

You can enlarge the features of a photograph by superimposing a square grid on it. Noting the position and size of forms within squares on the original, transfer them to a larger grid drawn on paper, carefully checking where shapes cross grid lines.

You can select areas of photographs and then recompose them by adding or deleting various elements, as I did below.

I decided to add life to the scene by including swans on the lake, people walking by and smoke curling from the chimney

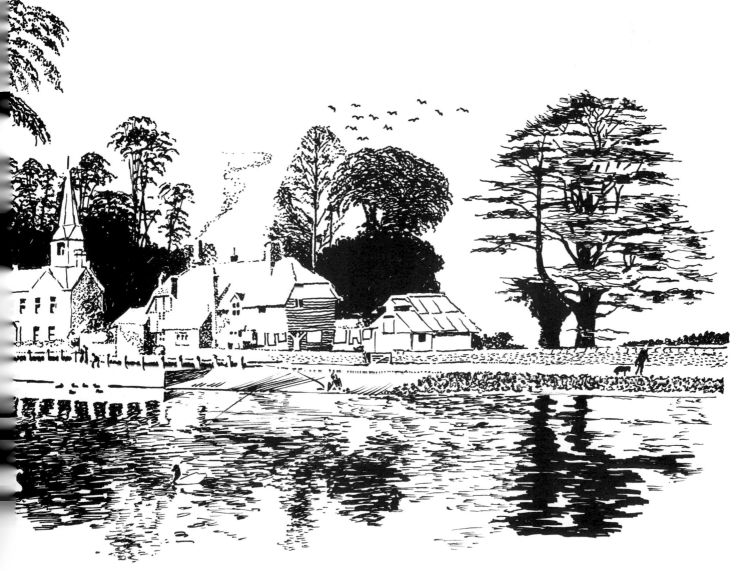

Looking After Your Drawings

Fixing

It can be infuriating to discover that the results of days of careful work have been ruined because a drawing was unprotected. Some media are vulnerable to careless handling.

Pencil, pastel, charcoal, conté crayon, chalk and wax crayon drawings all smudge easily. You can protect them by using a diffuser to blow fixative solutions gently over them, or by using an aerosol can of fixative. Stand about half a metre away from a drawing to cover it evenly. Let the fixative dry before you handle your picture.

Storage

You'll want to frame only your most impressive drawings, but don't throw away less successful ones – they record your progress and may even inspire you to redraw the same scene at a later stage. All artists have unfinished landscapes that they hope to complete at a future date.

The safest way to store drawings is on a large, flat surface, ideally in a drawer. Making sure that any fixative has set, interleave different drawings with sheets of clean, protective tissue paper.

I didn't want to lose the soft focus, high contrast effect of these charcoal lines on watercolour paper, so I protected the drawing with a fixative

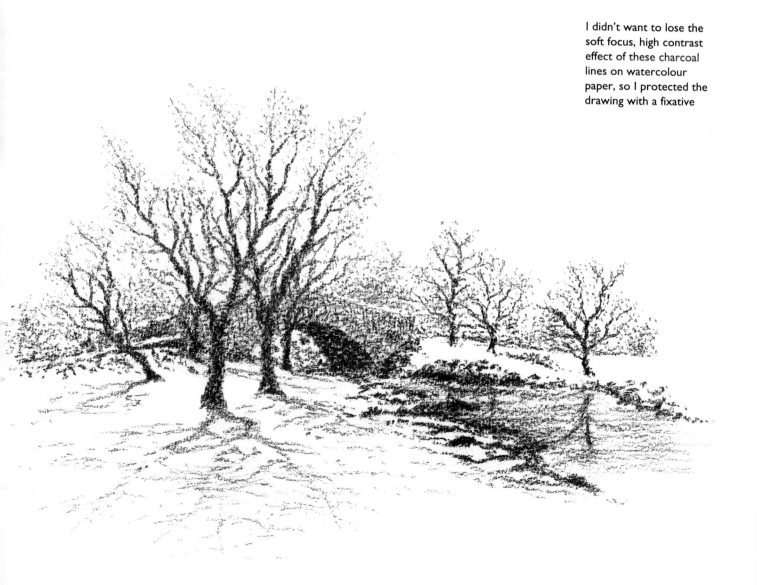

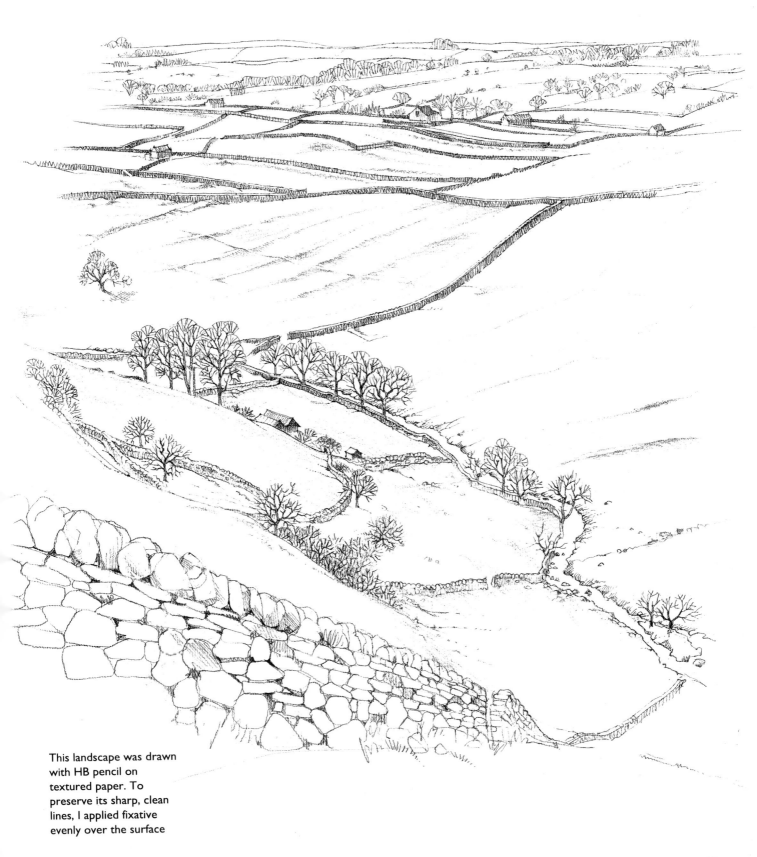

This landscape was drawn with HB pencil on textured paper. To preserve its sharp, clean lines, I applied fixative evenly over the surface

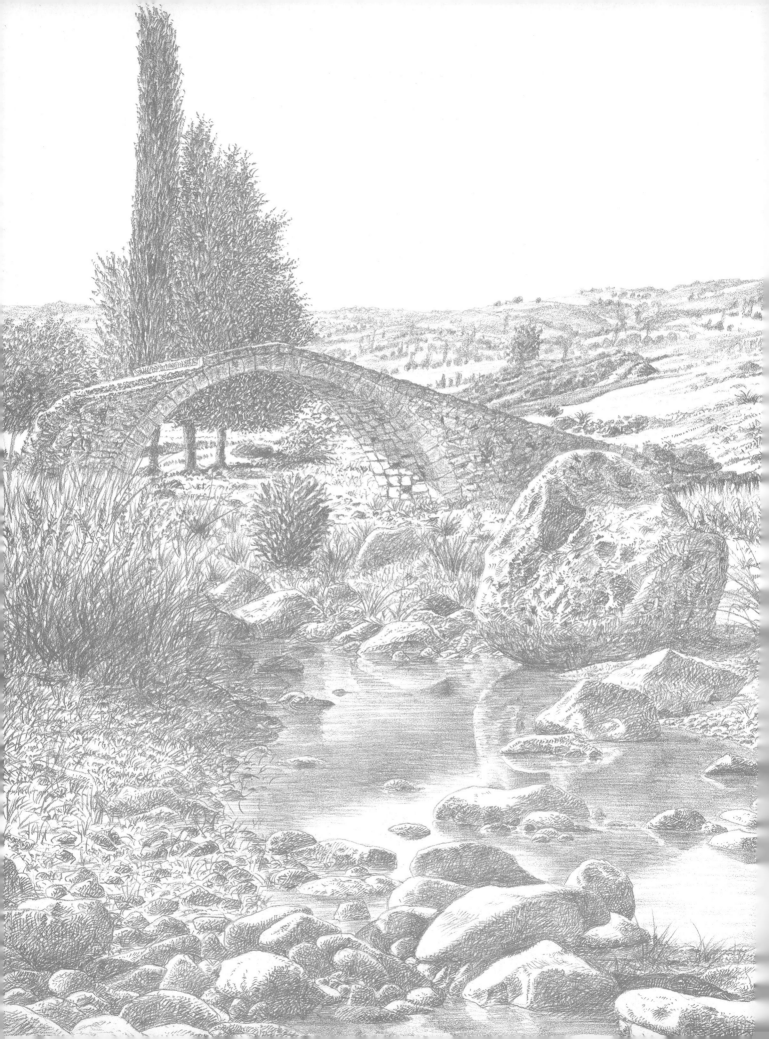